Dear Jelani":
Happy Birthday!
I wish best of the best
for you & also I hope
one day you'll be a
wonderful "guitarist".
as you are in other majors.
So I guess this will
always reminds you
of me.
Best regards,
Lida Sharifpour
Apr. 28. 07

LIGHT STRINGS

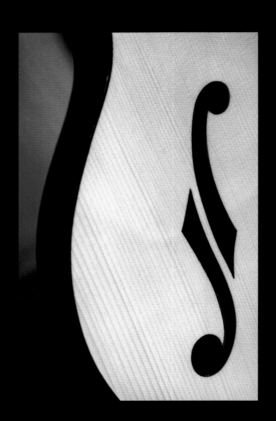

LIGHT STRINGS

Impressions of the Guitar

PHOTOGRAPHS BY RALPH GIBSON

TEXT BY ANDY SUMMERS

CHRONICLE BOOKS

SAN FRANCISCO

Timbre -Tenor -Tone

Consonance - Dissonance

Resonance

Library of Congress Cataloging-in-Publication Data
available.

ISBN 0-8118-4324-6

Manufactured in Hong Kong

Designed by Ralph Gibson

Distributed in Canada by Raincoast Books
9050 Shaughnessy Street
Vancouver, British Columbia V6P 6E5

10 9 8 7 6 5 4 3 2 1

Chronicle Books LLC
85 Second Street
San Francisco, California 94105

www.chroniclebooks.com

am a guitar addict. The vein was struck at the age of thirteen when, in a moment of epiphany, I saw Eddie Cochran on TV rocking out with a fat Gibson strapped to his body. From a small TV set, a deep blue twang emerged and bathed the room in blues and sex. This is where it started.

At fourteen, I worked during the summer as a photographer on the seafront of my hometown, a faded resort in England once home to Mary Shelley, Robert Louis Stephenson, and Thomas Hardy. Here in the green hills of Dorset, it took over—this obsession, this need, this lust for the guitar.

I worked for Mr. Wilkes. He was the owner of a wooden hut, a photo booth at the entrance to the pier, where he employed six boys as cameramen. Each morning we would be handed a large, clunky camera set at f8 1/25th and a bunch of tickets. We were expected to shoot six rolls a morning, counting the number of rolls shot and entering it into a ledger. Wilkes was exacting and mean, a bastard.

I worked seven days a week through the summer heat, spending every morning like Mr. Punch's crocodile, snapping away at people's ice cream–flecked faces as they came off of the pier with their hair blown wild by the sea wind, the girls in big flowery skirts, the men in summer blazers and cuffed trousers. I would go down into the hot sand and photograph sticky little kids with their mums and dads, sullen teenagers, and people from the north. After a while I could weave my way like Nureyev through the tightly packed mass of deck chairs, shooting noses, faces, teeth, squinty eyes, and arms raised against the sun. I passed out tickets of redemption like confetti, St. Francis in the sand.

At lunchtime the world grew fat and somnolent, and I returned the camera to the booth and went to sit

mine. I carried a small backpack that contained items vital to my existence (cheese and cucumber sandwiches, apples), but also, breathlessly important to me, a catalogue of guitars—guitars from America: Gibsons. I devoured the sandwiches and the catalogue alike. The catalogue was filled with pictures of paradise: the Firebird, the Moderne, the Flying V, the Byrdland, the Super 400, the ES-175—exotic and mystical, these were machines that would confer upon their owners the power of the shamans.

The pages also displayed photographs of many players. On one hand, you had jazzmen like Tony Romano, Muzzy Marcelino, John Pariso, Harry Sanpietro, Tony Coluccio, Tony Sunseri, Johnny Spaghetti, Asti Spumante— there was a distinct Sicilian quality uniting these men. I imagined that their guitar cases were probably full of bullet holes or contained pistols along with their spare guitar strings. Jesus, I thought, if I owned one of those things, I could probably make someone an offer they couldn't refuse. On the other hand was the country music set. In cowboy outfits and large sombreros, you had Tex Ritter, Gene Autry, Merl Travis, the Murray Sisters; they all looked kinda lonesome.

I lay back on the sand, the salt and brine filling my nostrils and curling the pages of my catalogue. I drifted off and dreamed of dark curvy wood, hands flying over frets, the great American guitarists, my favorites, the jazz cats—Jimmy Raney, Tal Farlow, Kenny Burrel, Johnny Smith. Frets, pickups, strings all seemed so far away. . . .

With a shock I felt something wet and cold, the tide was in and disappearing up my trouser leg. Lunch was over. I got up, shook the sand off my catalogue and hiked back through the sand to the promenade

by a head filled with guitar exotica—curly maple, reversible string saddles, mahogany and pearloid parallelograms—my focus was gone. I stared out at the English Channel, emerald under a cloudless sky. The sweet smell of candy floss filled my lungs, the cries of lost children crowded my ears, I was dispossessed; but there to save me, poised like the Mona Lisa over the still and sultry ocean and calling to my soul like a Lorelei, was the vision of a Gibson.

Reality was a Voss, a cheap German guitar made of plywood; I called it "the un-Gibson." However, it was what I had, and I practiced on it in my bedroom like a fanatic. Surrounded by a pile of long players and song sheets, I copied licks made on Gibsons. I listened to Wes, Kenny Burrell, Jimmy Raney, Barney Kessel, trying to work out how they did it. I listened with a couple of friends, other kids who loved jazz; we sat on each other's bedroom floors and tried to work out the chords and improvsations of the maestros. I propped my Gibson catalogue upright on the mantelpiece so that the first thing I saw every morning was the G word, spreading

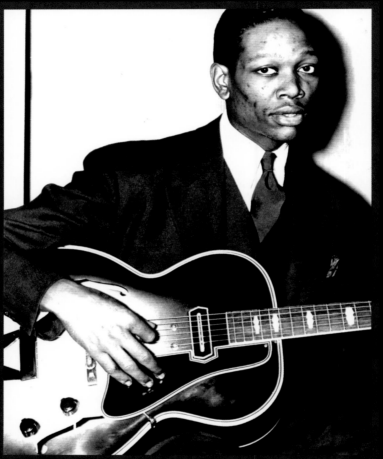

power through the room. I fervently believed that if I kept practicing, kept the image in mind, I would get one eventually and the un-Gibson era, the dark ages, would come to an end.

Three years later, I was bathed in a new light, a golden glow that emanated from the Godhead, the source of all being—in fact, from the honeyed sunburst of a Gibson ES-175 hanging on the wall of Selmers, in Charing Cross Road. There she was, and after what had seemed like a lifetime of hard labor, I now had the required cash for possession. We returned home together, she and I, Ms. ES-175.

I went straight to my room for the unveiling. She lay there in her case on my bed, a bride in pink crushed

velvet, the dark sunburst glowing under the incandescent light. I pulled her out, tried a few chords . . . G^{m7} – $C^{7\,\#9}$ – F^{m7} – B^b13^b9 . . . , yeah, it was good, it was very good, in fact, it was great: all that the rhetoric promised—even tone response, low action—she was fast, sexy, a player's instrument . . . , the promised land was here. I ran my hands over the carved top, the curve of the bout in direct line from the great Italian violin makers, the rosewood bridge, the pearl inlay, the mahogany; all converged to produce sweet music of the soul. I touched her dark curves, the deeply female curves of her body and something stirred inside of me, unfolded and spread its wings, took flight.

I was now a Gibson man, a "Gibsonian." The dream was in my hands, it was real, tangible, I was in the continuum, my licks started to sound better. Feeling smug and cool, I wore a faint Mona Lisa smile. I occasionally laughed out loud for no apparent reason. I felt slightly taller and became somewhat condescending to other so-called guitarists. Standing in front of the mirror and trying various poses, I affected disinterest, a world-weary look (actually an incredible-player-but-kinda-bored look), cool—yeah, a cool cat. I just happened to have a Gibson, I don't know how I got it. . . . My hair grew longer, I got a black suit and wore sunglasses at all times of day and night—even while sleeping. I wanted to be Miles . . . Coltrane . . . Sonny. I hung around Lenny's Record Store as if it were a sweetshop. Lenny sold Blue Note records. It was the coolest record store in our town, but to Lenny, I was just a kid, and I couldn't possibly understand the sophistication of the New York jazz scene. He told me that I would never make it, but I persisted in hanging around the store, fingering the stacks of records and obsessively reading the liner notes, so eventually he

eleted and began feeding me arcane pieces of inside nformation about the music that we both loved. One night he finally heard me play Wes's solo on West Coast Blues, and with a sardonic look on his face told me that f I kept playing I might just. . . . The dream was shattered a few months later when I was in a local park on a beautiful, sad October day. With clusters of leaves drifting down from the trees into the pink crushed velvet of my open guitar case, I demonstrated the position for the F chord to a pale young beauty. She turned and ran across the park. I chased after her leaving my guitar on the bench; and when I returned, the guitar was gone. Gone, Gibson and girl. Night descended. My bride was gone. A period of deep mourning and suicidal depression followed, along with an extensive police investigation, to no avail. Then one afternoon the phone rang. Joy. I was to be paid in full by the insurance company, who, somewhat out of character, had taken great pity on me, poor young lad that I was.

My spirits returned. I looked forward to scoring the Gibson II. I scanned the catalogue again, this time under the influence of Grant Green, a Blue Note guitar star. I decided to go for the ES-335, a beautiful slim-line model with a center block to prevent feedback. It was a hot new item of the Gibson production line. In short order, I whipped to London and back, and returned with the new guitar. I continued on, completing my cool with a French girl-friend, a Juliet Greco look-alike with coal-black eyeliner and a roll-neck sweater; her name was Mylene. I went to Paris to see her and stayed with her in her parents' house on the Boulevard Hausmann in St. Michelle. An expression of distaste crossed their snobbo Parisian faces when I turned up with my 335 and then proceeded to practice obsessively in the tiny bedroom at the top of the house. I was not what they wanted for their

daughter, and two weeks later I slunk away. I returned to England, bruised but still playing, bride number two swallowed by the night.

I returned to Paris one year later with my friend Dave Wilson, another guitarist. We crossed the Channel on a wind-lashed day and hitchhiked to the capital. We stayed in a tiny room on the Rue de la Huchette, above Le Chat Qui Peche, a jazz club in the cellar of the building, which that week was featuring a drug-ravaged Chet Baker playing with an unrhythmic rhythm section. I listened to Chet, and although I couldn't articulate my feelings about the music, I realized that something was wrong. I felt the soul in his playing, the heartache and the pain. I left and walked all the way to the Blue Note on the Right Bank and stood outside, forlornly looking at the photographs of the great musicians inside Kenny Clarke on drums, Jimmy Gouley on guitar and an unknown French organist. As I stood there, a middle-aged American couple walked up and asked me who was playing. I gave them an enthusiastic and informed rundown. They paid and took me in with them.

Inside the club Jimmy Gourley was playing a Charlie Christian guitar officially known as the Gibson ES-150. It had a fat single bar pickup, which was in itself an icon of jazz-guitar playing. He played "The Night We Called It a Day," "Anthropology," "Round Midnight." I sat in the small, dark booth with my new American friends. Mesmerized, I watched Jimmy's fingers fly over the neck of his ES-150, the stream of improvisation melding with Klook's relentless Turkish cymbals, the frets beneath his fingers a band of golden mirrors flashing under his inspired geometries. Magic. I was spellbound; I wanted to do what Jimmy G did with such ease. How to get there? I said good-bye to my friends and wandered off into the Parisian night, scared but on fire.

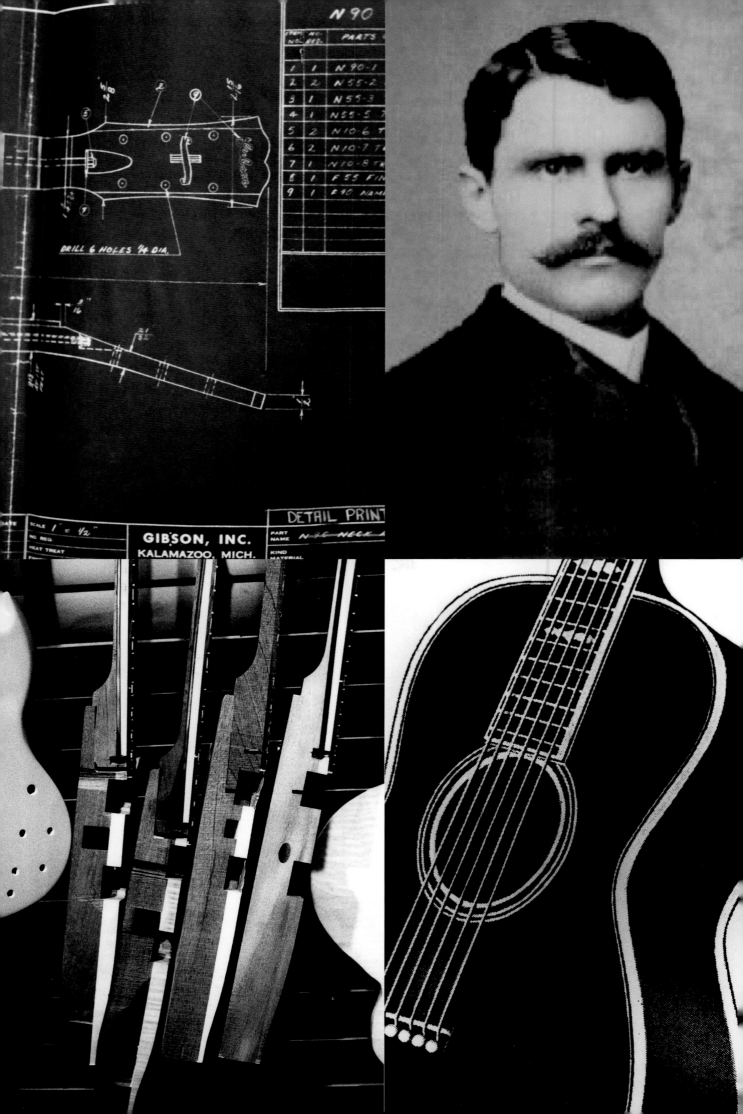

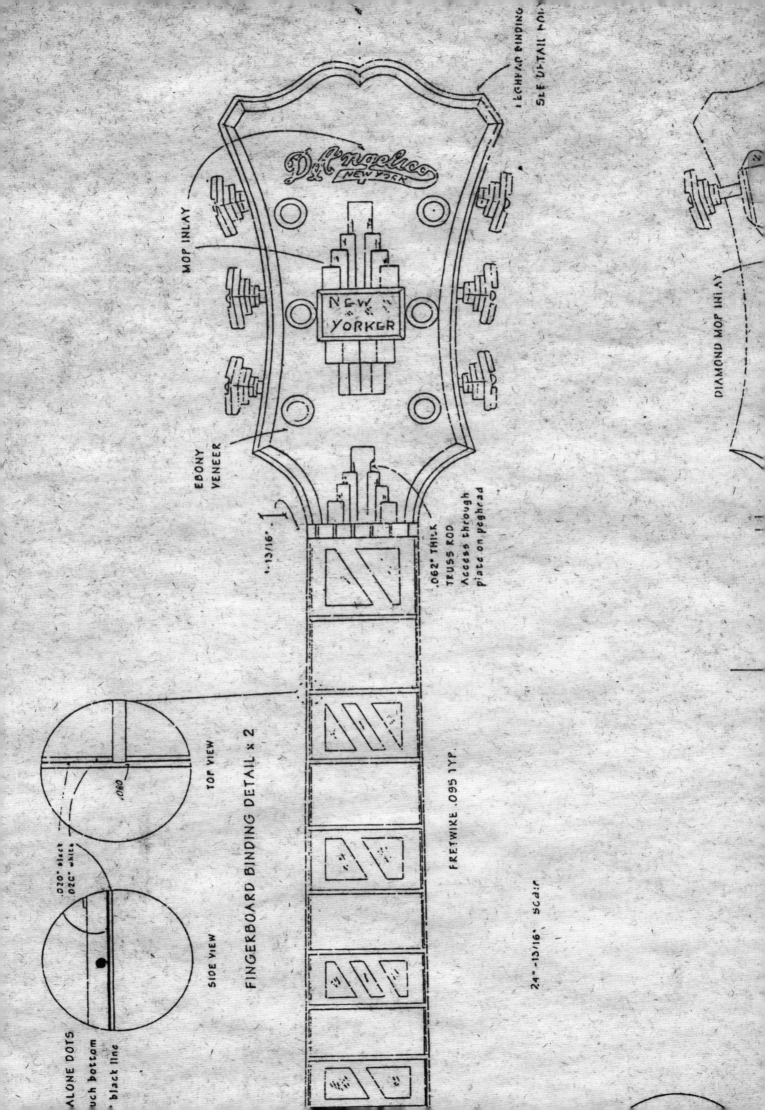

D'Angelico
NEW YORK

NEW
YORKER

MOP INLAY

EBONY
VENEER

LEGHEAD BINDING
SEE DETAIL HOLE

DIAMOND MOP INLAY

.062" THICK
TRUSS ROD
Access through
plate on peghead

.13/16"

FRETWIRE .095 TYP.

24" 13/16" SCALE

FINGERBOARD BINDING DETAIL x 2

TOP VIEW

SIDE VIEW

.060

.020" black
.020" white

ALONE DOTS
uch bottom
black line

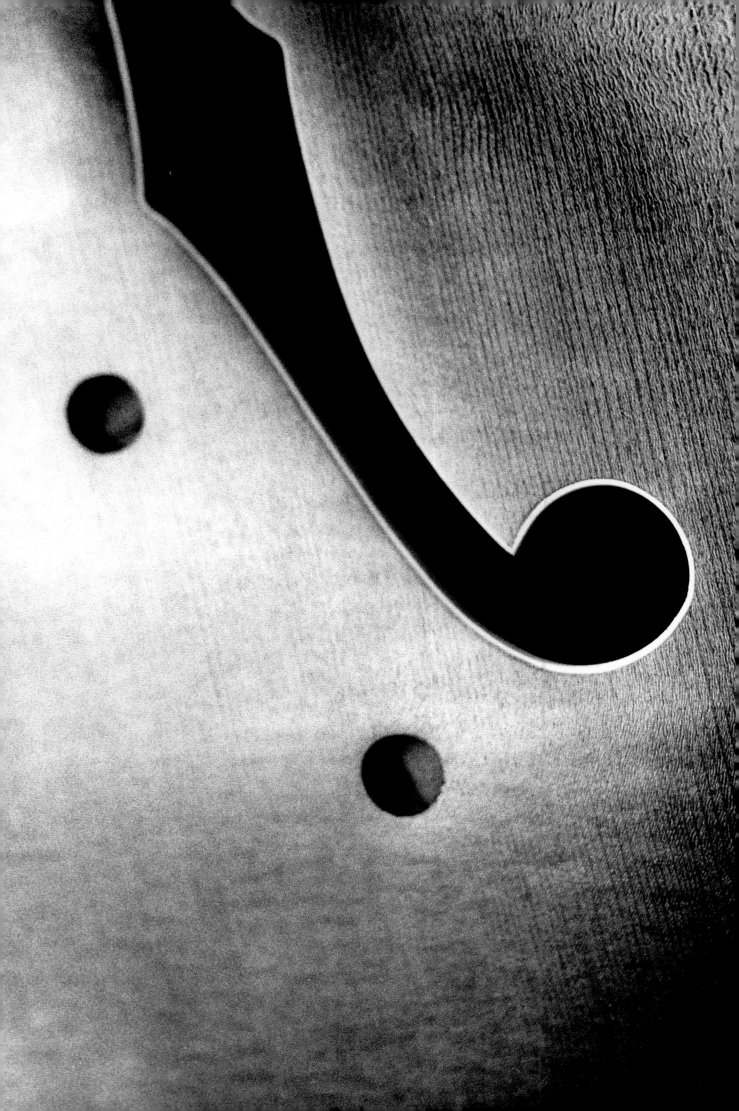

wood lives and breathes like warm flesh. Since it first brought heat and comfort in the form of fire, it has been a medium of expression for the human drama. Carved and pressed into the form of a guitar, it vibrates and dances under hand and string, expands and shrinks softly with its tonesong. Male and female, hard and soft, the tonewood, quick and pulsing, shifts shape under the luthier's touch.

To bring a guitar into being, the luthier must gain through time and experience a deep knowledge of wood and its many characteristics: flexibility, moisture absorption, warping, porosity, mechanical strength, and natural beauty. The luthier of experience will ultimately be able to intuit a piece of wood, and to use the Spanish term *dar a luz,* to give it light, in the sense of the birth of a child.

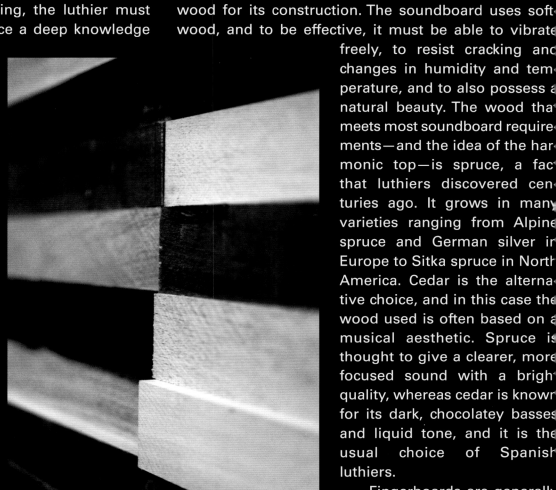

As a pre-echo of the guitar, the tree, while still in the ground, will come into consideration. The best place for a tree that is being considered as wood for instrument-making is on the side of a mountain or on dry rocky ground where, because of the dryness, the tree is forced to grow more slowly. A tree growing by a swamp or alongside a stream, on the other hand, will be wide grained and soft in texture, owing to a high-moisture content, which is not desirable in instrument-making. Some individual builders have a theory that it is best to cut trees only during a new moon. Although this idea sounds like a pagan belief, it is also built on scientific reason. When the moon is new it exerts less gravitational pull on the earth and therefore less pull of the sap up into the wood. This results in a dryer wood, which makes it lighter and less resistant to movement. In other words, the dry, light wood is a material that will have the most potential for vibration—a desirable quality in a stringed instrument.

Like wine, wood needs to be tended in the early stages; much as wine ages and comes to maturation and drinkability, wood also will go through a transfor-mative stage before being ready for the luthier's hand. Once cut, it must be carefully dried by air and stored inside with one end of each plank about six inches lower than the other. It is treated with preservative and then left for several years to let time and nature complete the oxidization process, during which time the cells of the wood crystallize and become even lighter.

Each part of the guitar calls for a different wood for its construction. The soundboard uses soft wood, and to be effective, it must be able to vibrate freely, to resist cracking and changes in humidity and temperature, and to also possess a natural beauty. The wood that meets most soundboard requirements—and the idea of the harmonic top—is spruce, a fact that luthiers discovered centuries ago. It grows in many varieties ranging from Alpine spruce and German silver in Europe to Sitka spruce in North America. Cedar is the alternative choice, and in this case the wood used is often based on a musical aesthetic. Spruce is thought to give a clearer, more focused sound with a bright quality, whereas cedar is known for its dark, chocolatey basses and liquid tone, and it is the usual choice of Spanish luthiers.

Fingerboards are generally made from either ebony or rosewood because they have the desirable qualities of being hard and wear resistant, which is necessary to hold a fret in place. Black ebony provides a great color contrast and is one of the hardest woods known although it can be brittle. Rosewood is almost as hard but contains a natural oil that increases its wear resistance and also has beautiful grain patterns. Ebony and rosewood are also used extensively for tuning pegs, bridges, and tailpieces.

Generally, the older the wood, the better it will sound, and the search for perfectly dried and aged wood continues as the perennial quest of luthiers around the world. Guitars have been made from old furniture, antique pianos, and famously (in Spain by

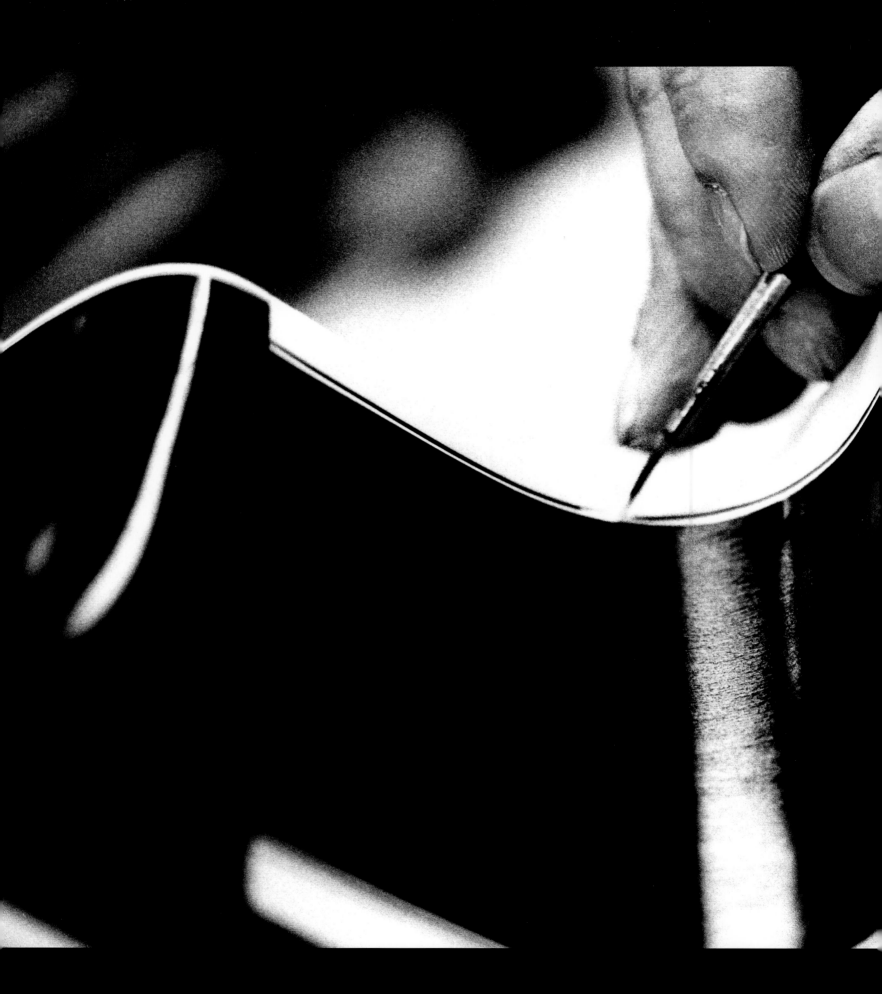

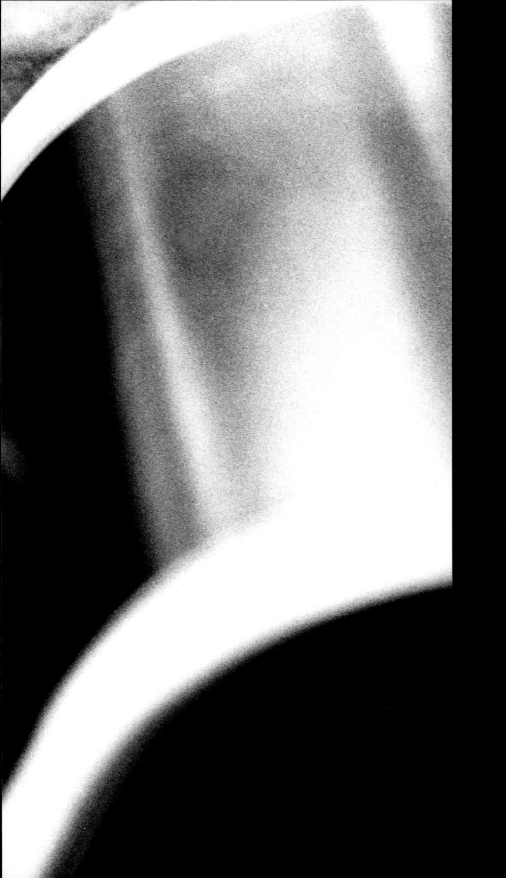

Miguel Rodriguez), from an old rosewood church door.

Building ships and building guitars are kindred processes. Wood must endure heat, cold, bending, and shaping to achieve a work of character and soul. Acoustic chambers of aged wood that can send the players a stream of notes spinning out past the moorish rosette are achieved only by the luthier who is in tune with the wood under his hand, the maker who caresses it with skill and is in tune with its soul. Wood is nature, music in inchoate form, and as the guitarist bends over his guitar, he orchestrates sun, rain, moon, and time.

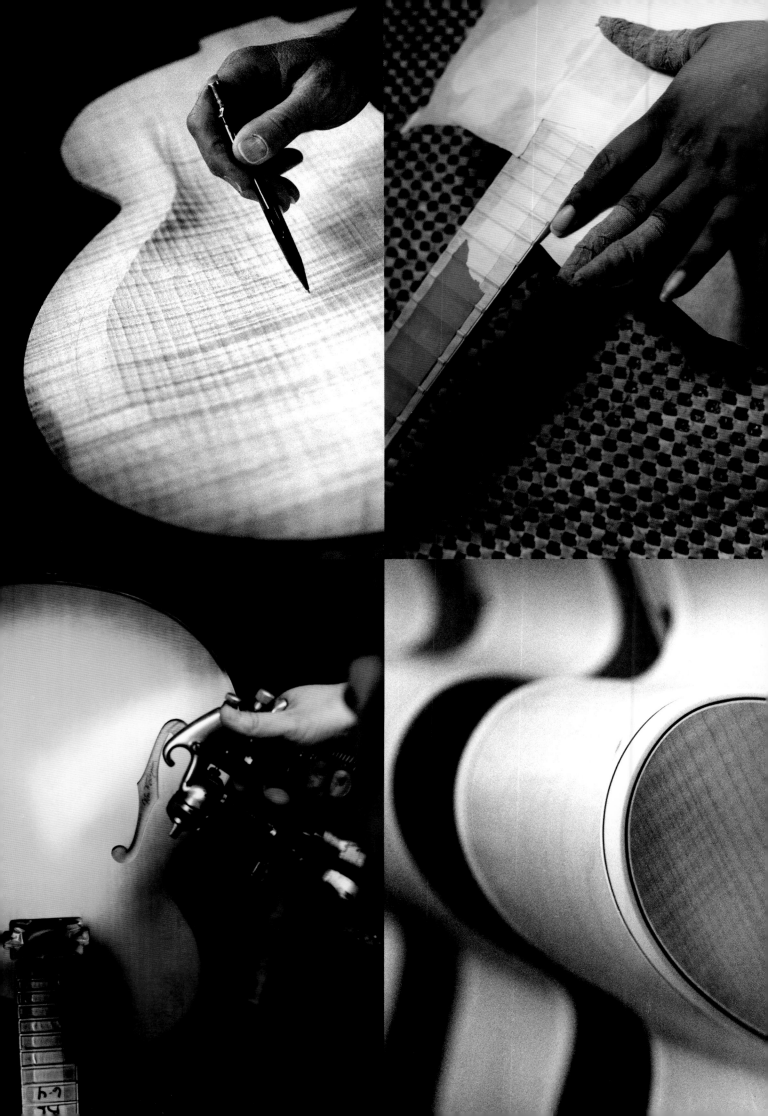

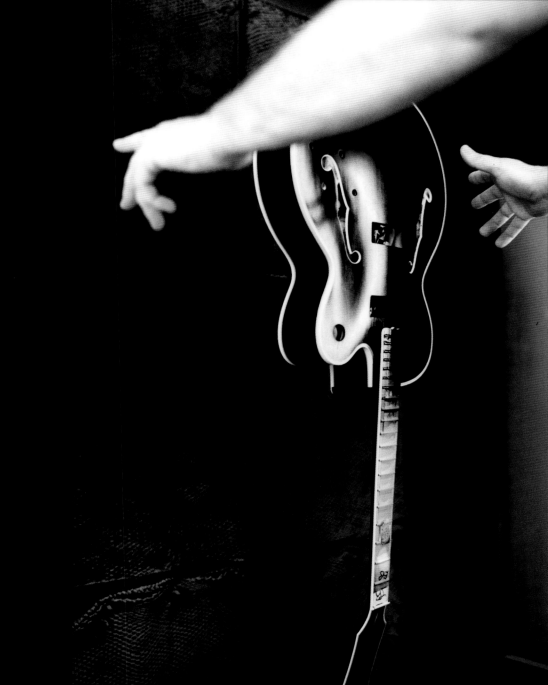

Shellac and linseed oil, mahogany, maple, and walnut, the twang of the ancient archer. The workshop—mystery, shadows, and magic—creation. Instruments hang from the walls in various stages of progress, they mirror the mercurial mind of their creator. He stands there, Orville the magician, staring into the distance. Shapes and curves play across his vision, dark and light wood, tonewoods, materials that will speak and sing. He will give them their voice. It lives in him—the knowledge. Strings, wood, old cultures, ancient instruments, yuechyn, bandurria, chittara, citern, vihuela, guitar, they crowd his mind and force his vision into a tunnel. He is impatient, he senses something, and stepping forward, he stares at a group of mandolins whose large round backs protrude into the space of the workshop. They frustrate him, too many parts, he calls them potato bugs. It would be better if the mandolin could lie flat on the body like a violin, if the back was carved from only two pieces—thick in the center, thin toward the edge.

Reduced to the simple single function of backbone, as a repository of electronics the solid wood–body guitar provides the electric pickups with a wall, a base from which to project. Despite the lack of a sound chamber, acoustic qualities still remain present and essential, and the type of wood and its density are carefully considered. Different woods like oak, maple, ash, or poplar are used according to the desired tone. The Les Paul is normally constructed from oak or maple, and these woods in combination with its famous humbucking pickups produce the thick, creamy sound that is sometimes known as the "sobbing woman."

Ash, alder, or poplar are used for the Fender Stratocaster and give the bright, popping sound typical of that guitar. The Gibson Les Paul and the Fender Stratocaster were both designed in the late forties and early fifties and have remained like fraternal twins as the two spectacular archetypes of solid-body guitar construction ever since. Icons of youth culture, they have spawned endless imitation but have never been surpassed as pure American genius.

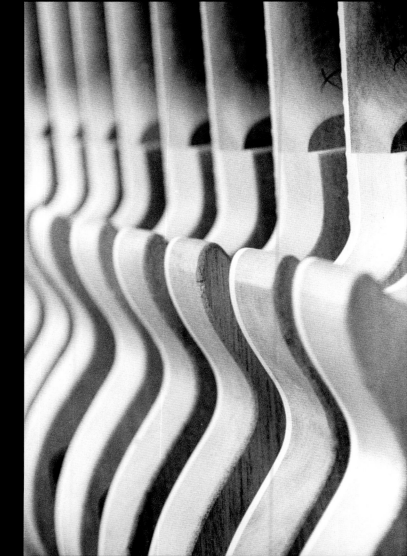

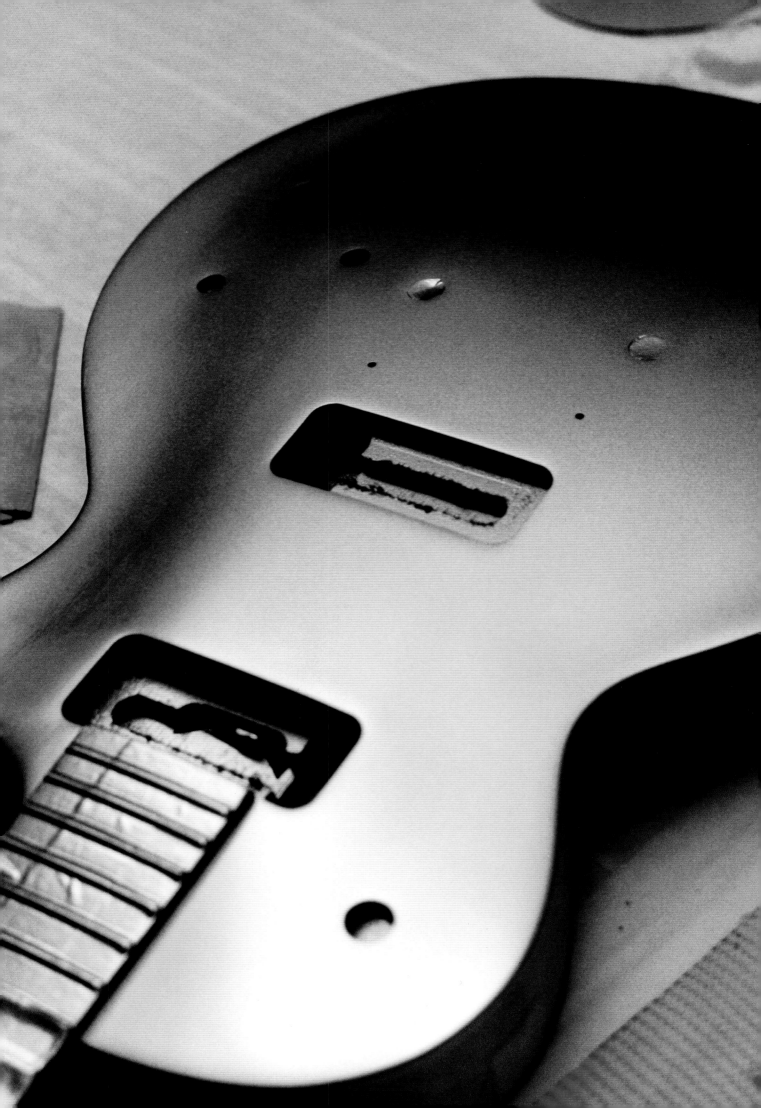

The guitar should be by definition unique, individual . . . with each instrument having its own character and particular sound, yet due to high demand guitars are made on a production line with the implication of uniform excellence. They are stamped with a number to signify the year of production and the position on the belt where each guitar sat with hundreds of others. (Send in the clones!) But, despite the leveling process of the factory, and the anonymity of the serial number, the invisible plays its hand and great guitars different from the others somehow emerge. Why is 7-0396 so outstanding, so playable, why does it feel so right? Sometimes, to the chagrin of the maker who desires to make all of his instruments equally good, he occasionally has to bow in the direction of the unseen. . . .

One of the ironies in instrument-making is that a maker will make one outstanding instrument that will give him a reputation and will considerably increase the prices of his instruments, but there is no guarantee that he will ever be able to reproduce his great instrument, despite trying to create in identical circumstances.

Throughout the twentieth century and the development of the electric instrument, guitars have been made on an assembly line, and the history and development of the modern instrument can be traced through the factories of Gibson, Fender, Epiphone, and Martin, etc. If the ideal musical instrument is unique in character and sound, with its special properties being defined by maker, materials, conditions, and the moment in which it was constructed, an assembly line for guitars therefore would seem to be a contradiction. But like a Zen koan, the cosmic joke slips into the process of instrument-making and the presence of the *Mysterium Tremendum* has to be acknowledged even if with a raised eyebrow.

The serial number is stamped on the back of the headstock, indicating its year of production and its number in the line. Perhaps there has been alchemy of wood, glue, and air.

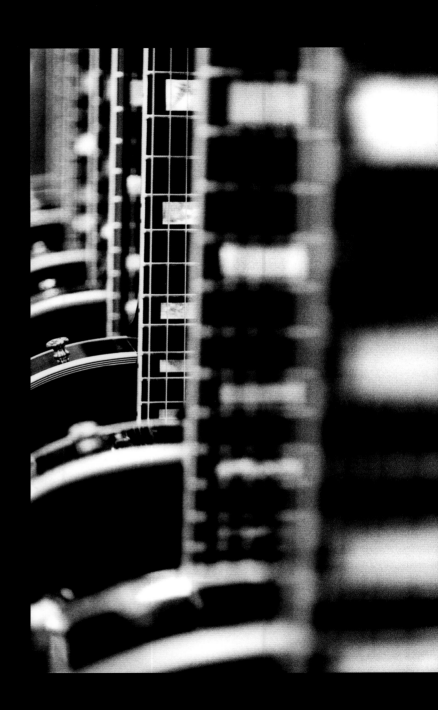

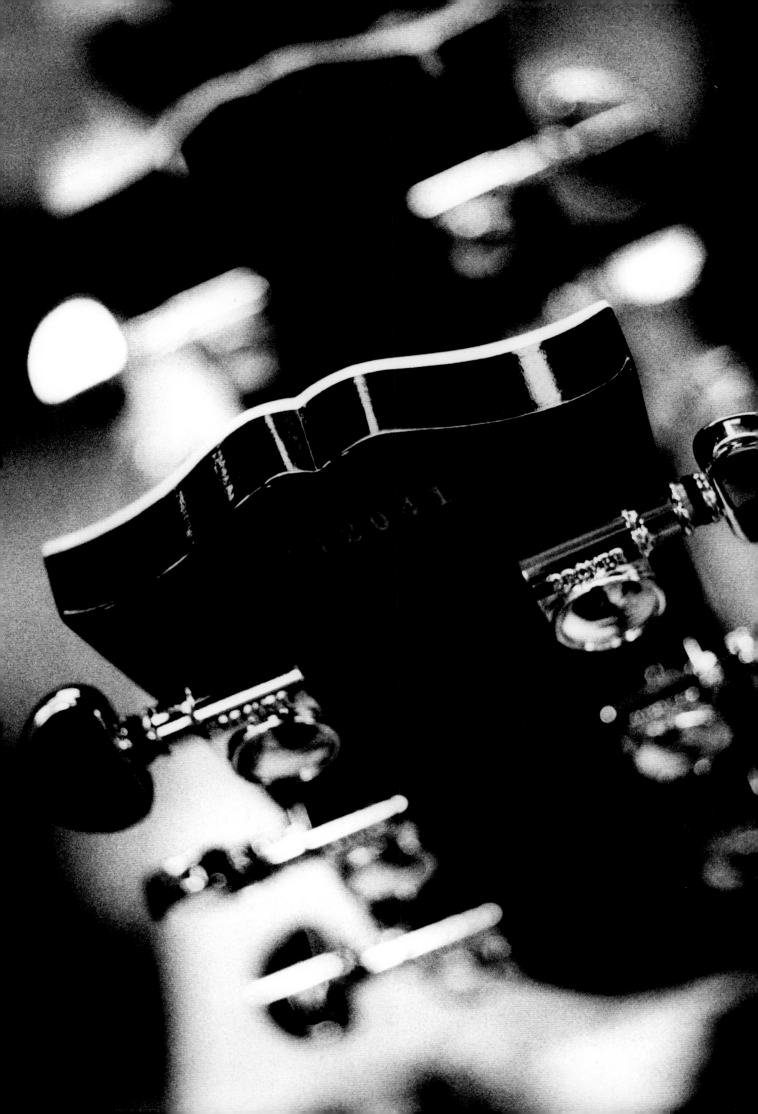

The bar pickup, otherwise known as the "Charlie Christian pickup," became synonymous with jazz guitar in the '40s. Big and heavy, it was placed on the relatively cheap ES-150 ($75) and needed three screws to hold it in place. The cobalt magnet with its 10,000 turns of no. 42 wire gave the note a thick horn-like sound that was perfectly suited for the emulation of a tenor sax. The guitar equivalent of Lester Young, Charlie Christian's playing was a sensation and caught the attention of guitarists everywhere. It was widely copied, and the electric guitar became a permanent fixture of the jazz scene.

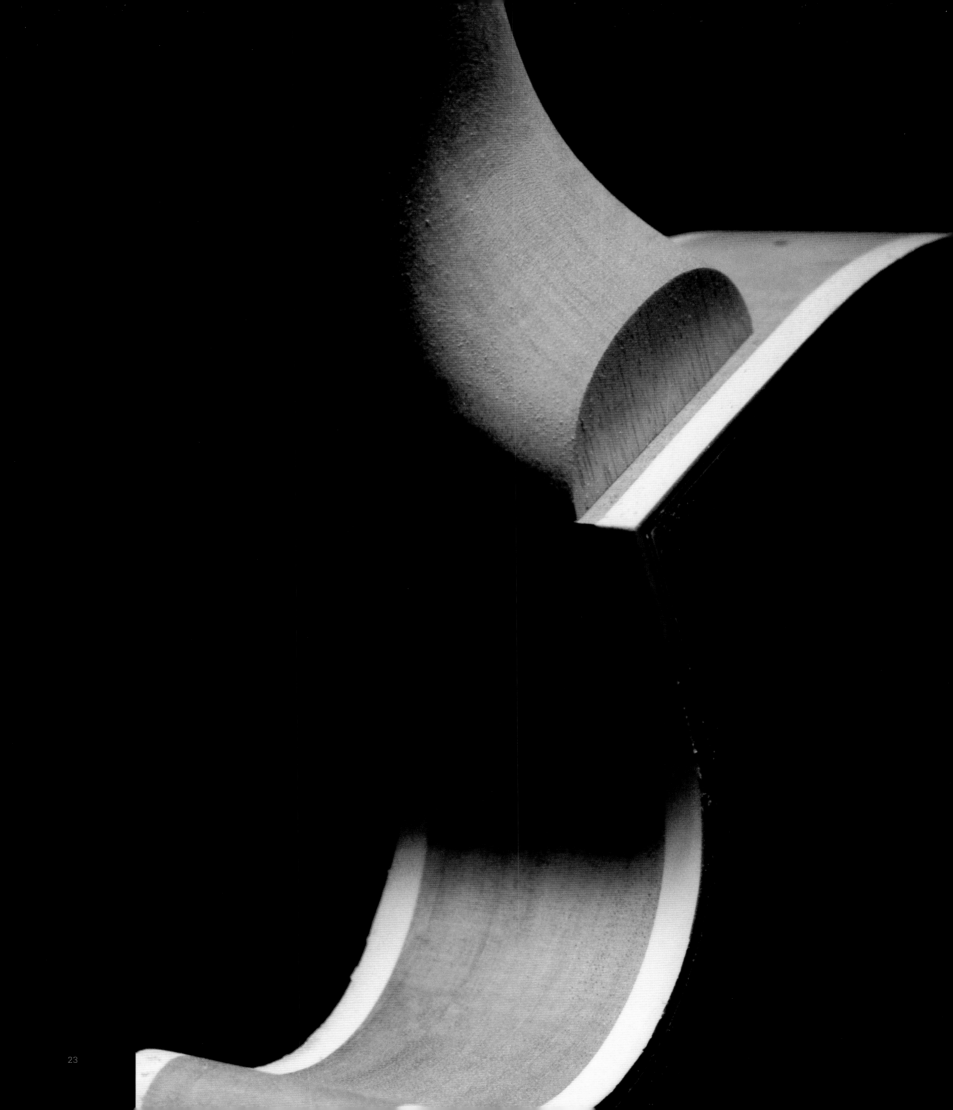

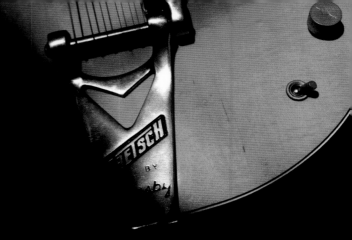

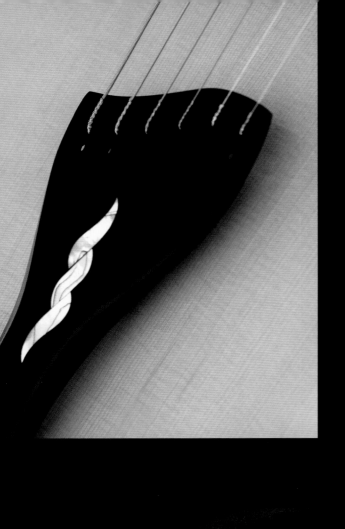

The tailpiece sits in the center of the lower bout and holds the strings in position after they have crossed the bridge. The styles and methods used to secure the strings reveal the history and ingenuity of the luthiers in their endless quest to anchor the strings and set free their vibrations. From the simple trapeze of the Gibson 1952 Les Paul Gold top to the ivory comb of a Robert Benedetto, the tailpiece mirrors the tuning pegs like the far end of a suspension bridge.

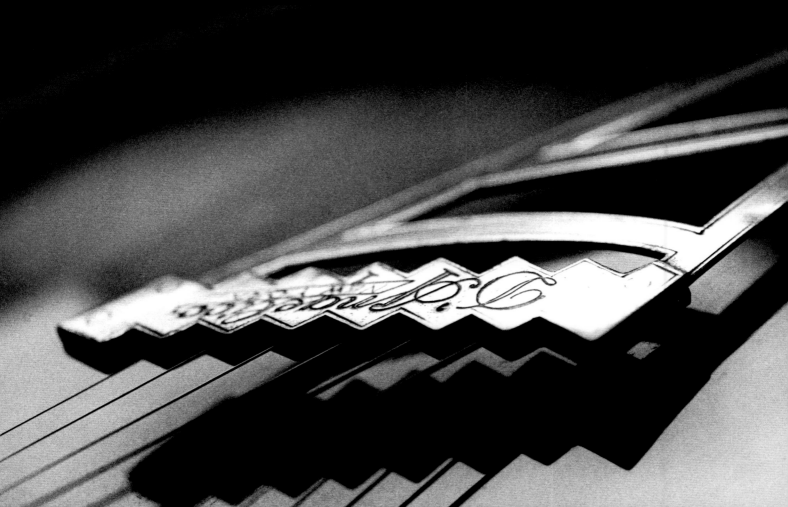

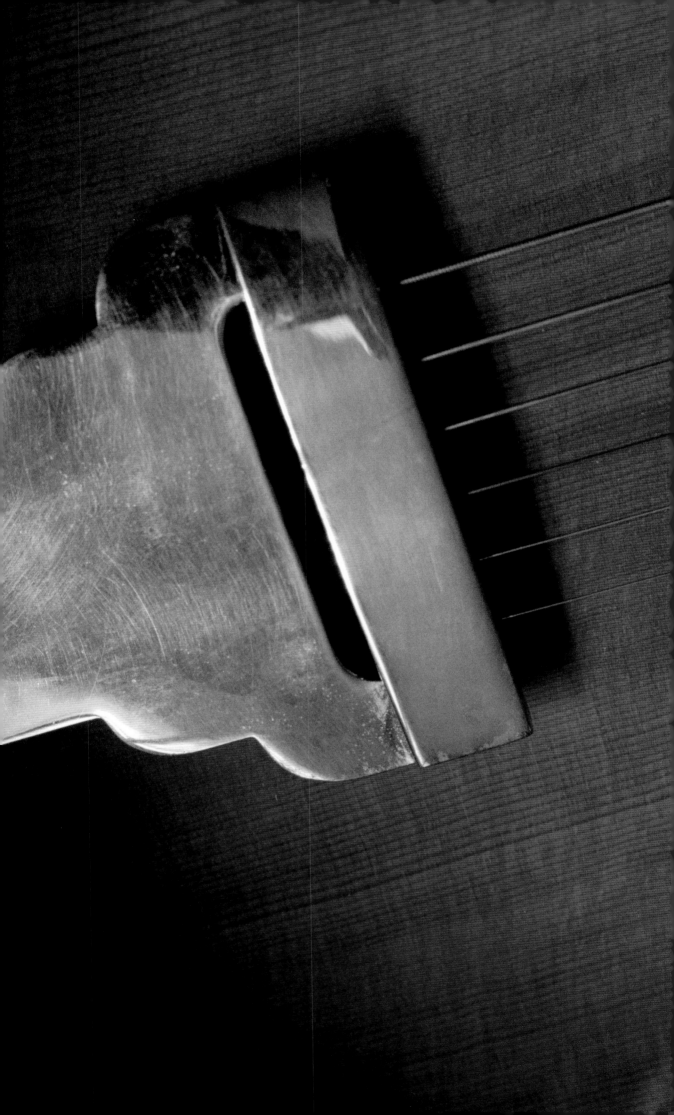

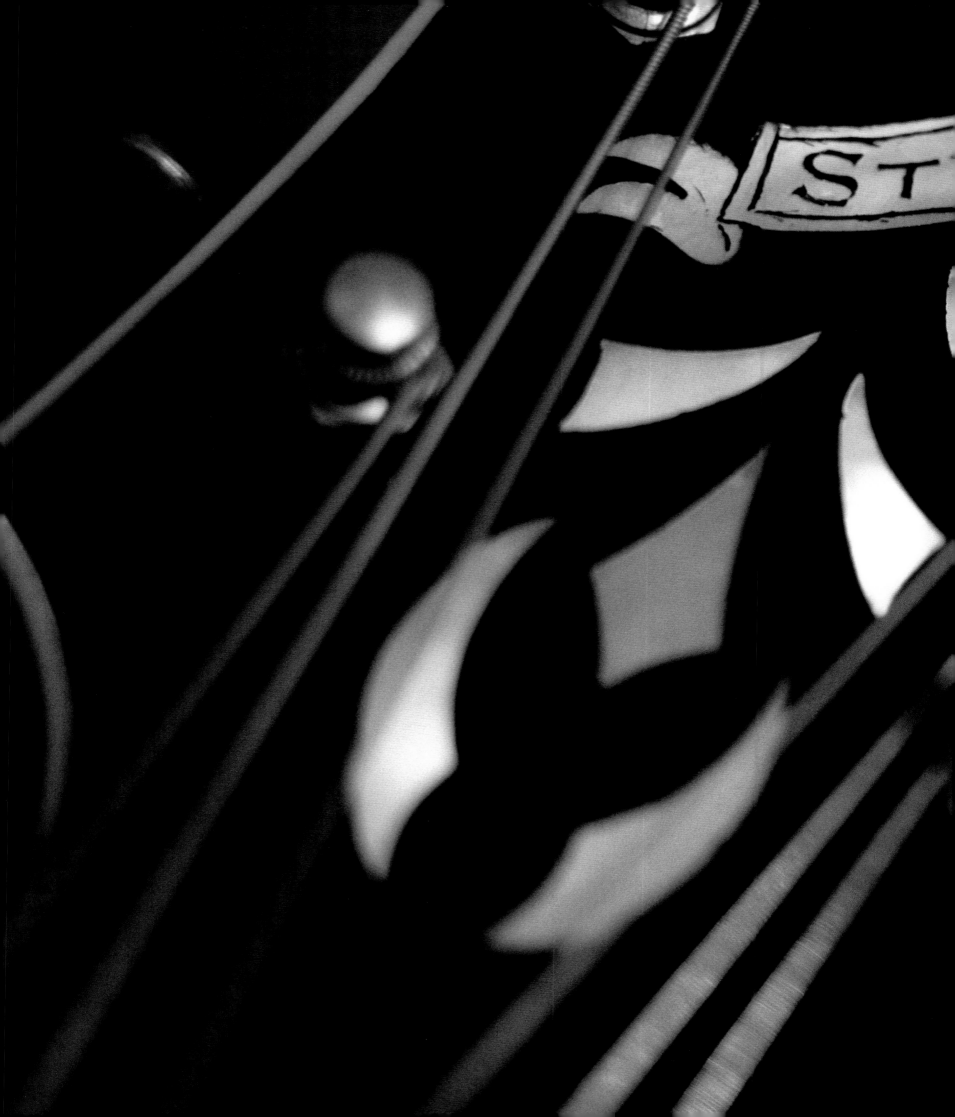

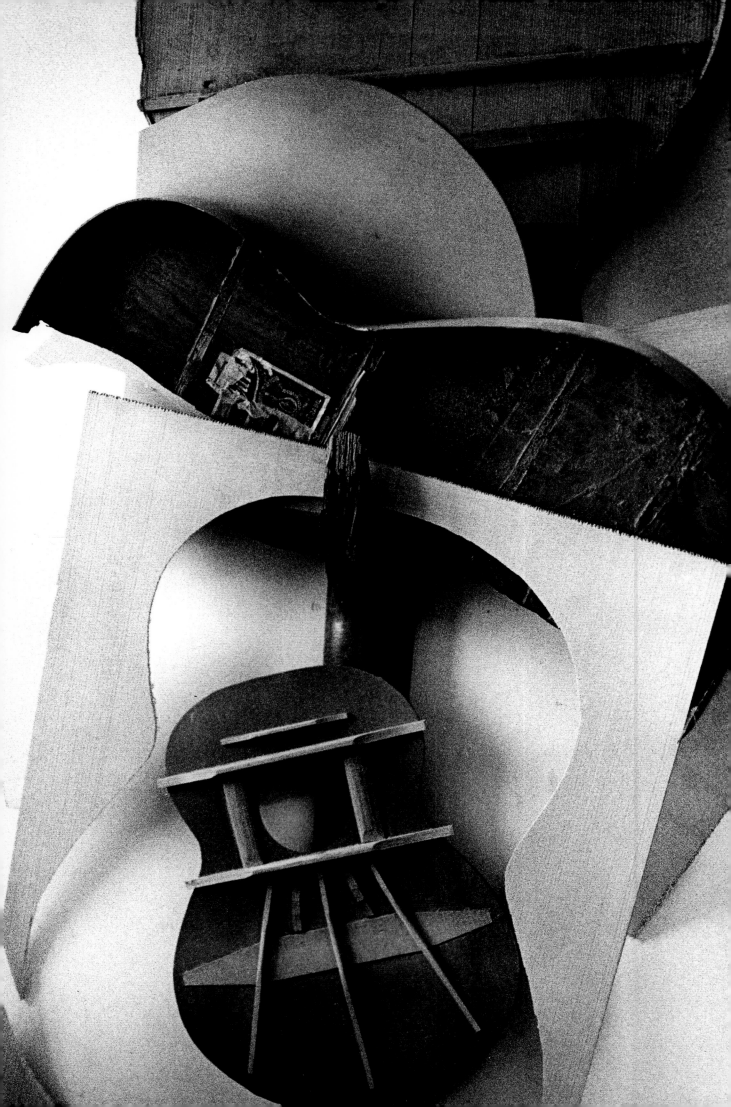

Upper transverse bar, lower cross strut, fans and head block, subtle architecture beneath the hand.

The guitar is a marvel of structural engineering. One of the most challenging parts in its construction is the bracing of the soundboard. The brace design is the sine qua non of guitar design and has been paramount to both the modern classical and steel-string guitars.

Although the rudimentary idea of fan bracing dates as far back as the 1650s, it was the brilliance of Louis Panormo and his variations on fan bracing in the 1840s that provided the gateway into the modern era. The great Spanish maker Antonio de Torres, however, eventually originated the bracing system that is still in place today with classical and flamenco guitars.

C.F. Martin in the 1840s, with typical American ingenuity, developed his own unique system of bracing in the form of an X. Although he originally tried it on the gut string, it soon became standard on the steel-string guitar, which was built in response to the demand for more volume at the turn of the century. Due to its bigger sound, the steel string with its X bracing eventually overtook the gut-string model, and Martin's X remains the standard bracing on acoustic steel-string guitars to this day.

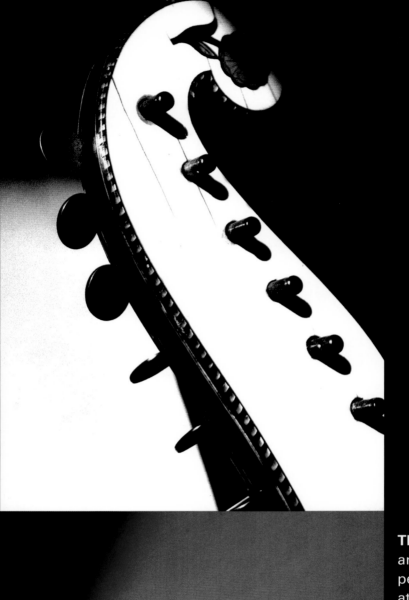

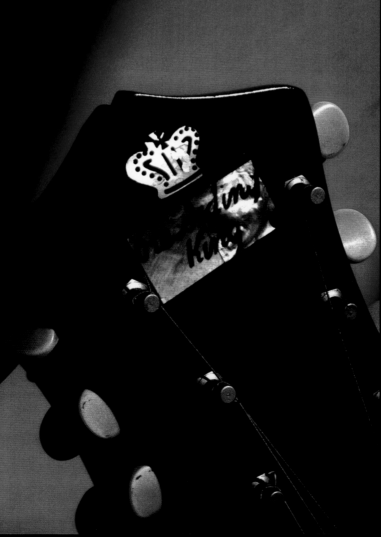

The head and tow[...]
pegs are [...]
at the op[...]
and orna[...]
echoes t[...]
the make[...]
pearl fle[...]
unsigned[...]

In [...]
typically [...]
1700 the [...]
hold and [...]
its zenith[...]

T[...]
Antonio [...]
headstoc[...]
the case [...]
it even c[...]
expressi[...]
the reno[...]
New York[...]

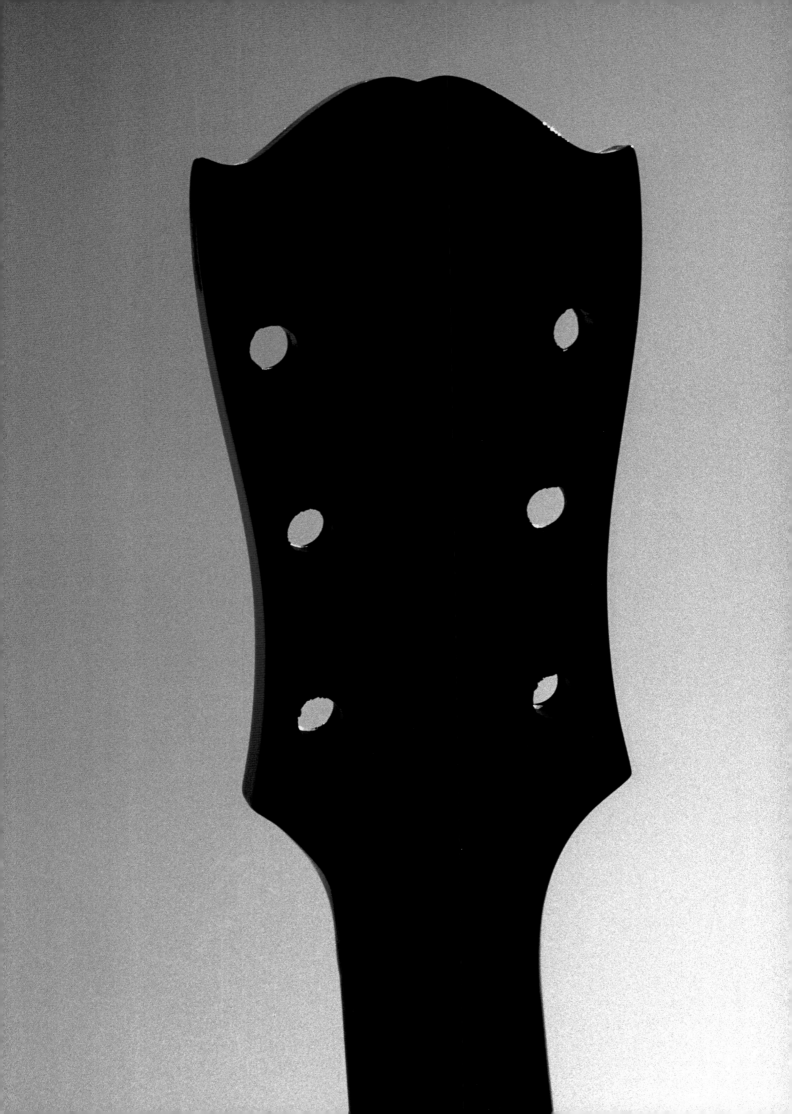

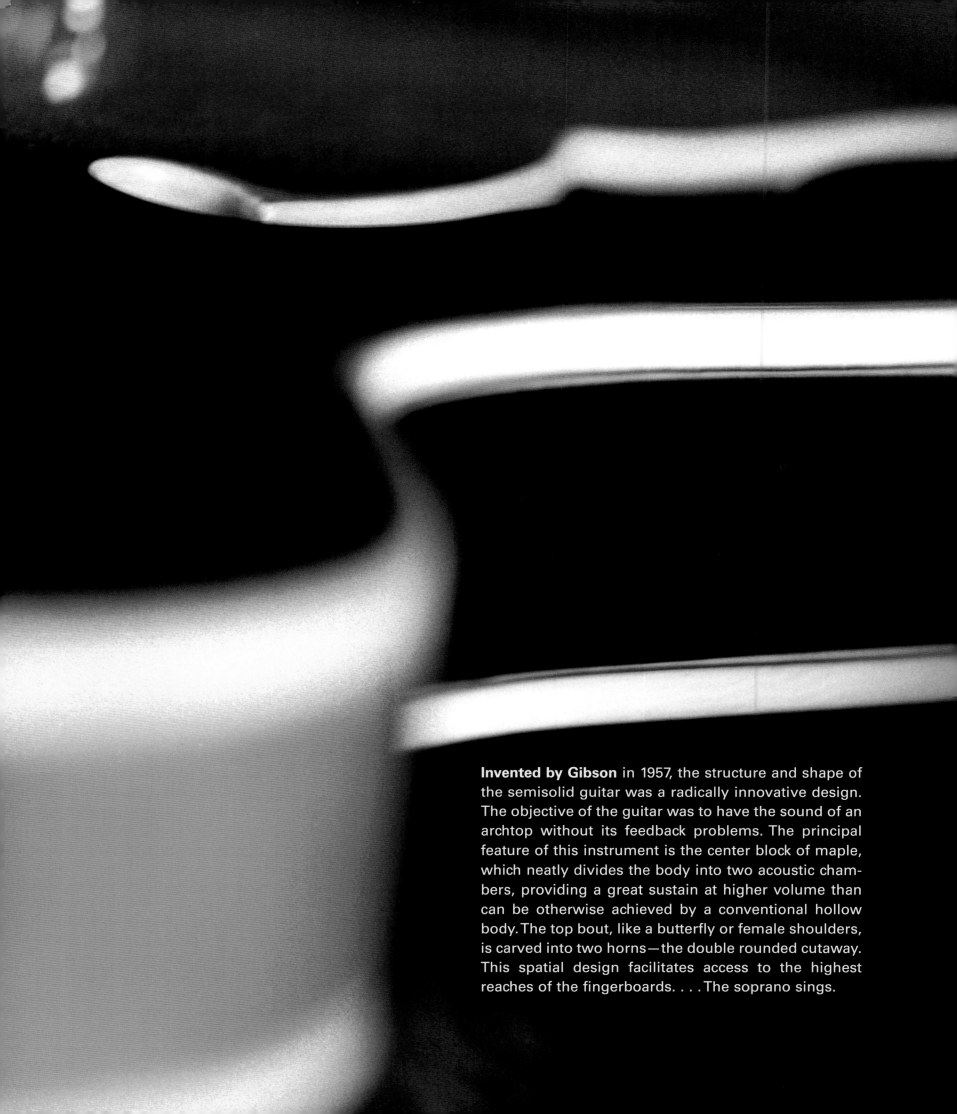

Invented by Gibson in 1957, the structure and shape of the semisolid guitar was a radically innovative design. The objective of the guitar was to have the sound of an archtop without its feedback problems. The principal feature of this instrument is the center block of maple, which neatly divides the body into two acoustic chambers, providing a great sustain at higher volume than can be otherwise achieved by a conventional hollow body. The top bout, like a butterfly or female shoulders, is carved into two horns—the double rounded cutaway. This spatial design facilitates access to the highest reaches of the fingerboards. . . . The soprano sings.

The Red Guitar

She had seen them the last time that they were here in her country. She loved their music with its jagged edges and impossible melodies. It thrilled her and made her a little bit crazy, especially when the March winds blew through the open windows of her grandmother's house, bringing the smell of sand, salt, and oranges that always rose like a spell at that time of the year. Then, she would sit by the open window and play the guitar music of Villa-Lobos to the sea. She would play fiercely to see if she could whip the waves into a frenzy. "Estudio no. 11" was good for that. Sometimes, when the sea was calmer, she would use the lapping of the waves on the beach as a metronome and play slow, languorous melodies of her own. Then she would grow sleepy and would go upstairs to lay naked on her little bed at the back of the house, the guitar beside her.

She would dream, and as always, images of them came to her, flying guitars and songs with choruses that repeated and looped in her head like a bird in the rainforest. She knew everything about them—their names, the foods they liked, favorite colors, who they were influenced by, even the names of their parents—their life was her life. Next week they would be here again, and she had thought it all through—the plan, the design, was perfect—and she would become part of the group in her own unique way.

The concert was sold out and it raged for three hours as the group strutted, paraded, and taunted the crowd with their guitars. She pushed to the front of the stage and wept with the other girls at the beautiful sounds that passed from their guitar amplifiers and over their heads in great waves. The concert came to an end and she walked slowly from the hall, stunned and silent. She always came alone to their concerts. It was too deep and spiritual an experience for her to be able to talk to anyone else. She felt that she alone among all the other young girls in the audience was the one who understood them. Her best friend, Laura, for example, always chattered like a parrot through an entire show, so this time she moved away from her friend and stood alone to take their pulses and vibrations into her body and mind.

It didn't matter which one it was, but it would be one of them. Nick, Sam, Johnny, Jet, or Carl.

She left, the spell of their music ringing like a church bell inside her head. It would take time for them to get back to the hotel; at this moment, for instance, they would be in their dressing room drying the sweat from their faces and bodies, lighting cigarettes and making jokes. She walked across the Botanical Gardens and into the lobby of the hotel where she had booked a room the day before, and where they were staying.

She went to her room and took off the clothes she had worn to the concert, and stepped into the shower, singing fragments of their songs as she soaped herself to a new radiance. After drying and perfuming herself, she slipped a red silk dress over her head, which accented the youthful curves of her body. Humming the beautiful melody of "Danza Paraguayas" by Barrios, she stared into the mirror and brushed her long, dark hair. Who could resist her? She had to admit even to herself that she was a beauty. The green eyes with the center flecks of gold, the silky olive skin. Her grandmother would look at her and shake her head and mutter something about her being even more dangerous than her foolish mother. She had the power to destroy men with these gifts, but she also knew that this God-given beauty was a weapon and must be used with care.

Naked under the red silk, she felt ripe like a fruit that is ready to fall. She slipped on the sling-back stilettos, picked up the little jeweled handbag that her grandmother had given her, and left the room.

At the bar she sat on a high stool and sipped a Belvedere—the only cocktail whose name she knew. With the red silk dress, she seemed sophisticated enough to be there and no one questioned her. Maybe the men in the bar were staring at her for different reasons, but she met their looks with an even gaze that made them look away, their imaginations inflamed even further.

The door swung open and they came in and saw her right away. "My god," an English voice croaked. She smiled at them, cocktail in hand, heart beating. Jet, the guitarist, came over to her. "Hello, what's your name? I'm Jet, would you like a drink?" "I have one," she said, feeling slightly drunk. "OK, well, how about another one—what's that?" "A Belvedere." "OK."

She let him talk to her for a while and she replied to all of his questions with a sweetness that seduced like a beautiful flower in the presence of a bee. He asked her if she would like to have one more Belvedere in his room upstairs, emphasizing that he had a very nice suite with a view of the sea.

They entered the room, which was filled with the soft light of the southern sky, the sound of the sea in

the distance giving the room a light insistent pulse. He put his guitar down at the side of the bed and then tried to embrace her, pressing his mouth passionately against hers. Her lips parted and their tongues intertwined like roses. She felt his hands on her body, as the red silk rose up her thighs like a butterfly. He groaned and she thought, "He's lucky—he can't believe his luck, that I chose him." "Just a minute," he broke off and disappeared into the bathroom. She let her dress fall to the floor, and then bent over and unlocked his guitar case. It was a red Stratocaster. She sat on the bed and pressed it into her body. The magic machine that had given her wings so many times. With its red lacquer fiery against her golden skin, the headstock between her breasts, and the body between her legs, she felt the guitar dissolve her senses and become liquid.

The bathroom door opened and he came out and stopped dead when he saw her. He smiled and moved to the bed, kissing her, the guitar between them. As they began an endless kiss, he twanged the strings and stroked a nipple; a laugh like a silver dove escaped her throat. Their lovemaking was deep and long as she reached to him with her entire being and engulfed him like an ocean around a small sea creature. The music of his group echoed in her head like a great chord.

He was lost in her, and he felt jungles, mountains, and rivers passing through him. This exotic beauty was the pinnacle of all his efforts. Her being seemed to be the sum total of all that he was trying to express on his guitar but—somehow this was it, the exquisite essence, somewhere beyond music. His head filled with her perfume: salt and oranges. Outside a macaw sang into the dark heat.

Their lovemaking subsided and became gentle waves kissing the sand, and he passed into a deep sleep. She rose and picked up the red Stratocaster and sat on the edge of the bed cradling it in her arms, and although the solid-body guitar without its amp sounded thin and muted, she leaned over his sleeping form and played the savage "Villa-Lobos Estudio no. 11." She slipped on the red silk dress and left the room.

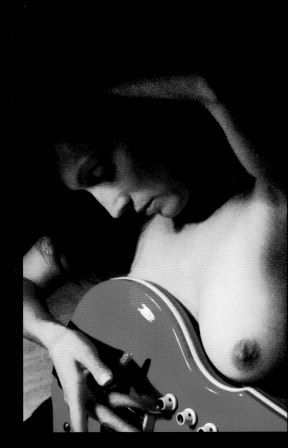

t radiates like a sun, out toward the edge of the universe, lightness to darkness—the
most basic and primordial dualism that a human being can experience. Like a flaring
comet, the sunburst spreads across the surface of the guitar from major to minor

Silky, velvety, stiff, heavy, buzzy, fast, light, and sexy are some of the words that guitarists use to describe the action of the guitar. When referred to, action generally means the height of the strings above the fingerboard, but the action of the guitar has many implications. It is a complex of resistance, pressure, speed, and control, and like the hummingbird, the strings hover over the fingerboard, never at rest.

For the guitarist, the action will be personal and may evolve from the type of music he wants to make, the way he imagines the sound of the guitar. It can involve a compromise between speed and ease with the inherent risk of tuning difficulties versus a higher, stiffer action that will be slower but more likely to keep the guitar in tune.

The fast low-slung action using light strings is often the choice of rock players as it gives speed and the ability to bend the strings beyond their natural resting place, but tuning may be sacrificed. Other players graduate toward a stiffer action, the strings raised higher over the fingerboard and heavier in gauge, and, with the use of a heavier pick, this creates an even resistance between the pick and the string, forcing the dynamic back into the touch of the player.

The action of the guitar is also known as its setup, which can include a thousand nuanced adjustments involving string weight, saddle height, nut, truss, rod adjustment, bridge height—all of which may be viewed as a palette of colors. The perfect combination of these results in an abstraction beneath the hand that can only be described as a feeling, and that has its real expression in the way the musician plays. String height, nut, saddle, truss, rod, bridge, and the beading of frets— building blocks of music. . . .

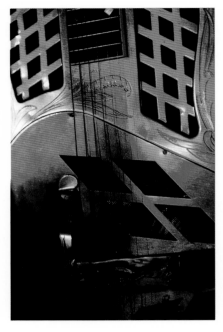

Triolian, Duolian, Spanish Neck Tricone, El Trovador, Estrallita, Aragon, Trojan, Havana, Rosita—the resonator guitar, with its unique look and sound, has achieved a legendary status in the archive of great American guitars. . . .

In the 1920s, an American vaudeville entertainer and guitarist named George Beauchamp had a problem: his guitar was simply not loud enough; the audience could not hear it. Frustrated, he tracked down a Czechoslovakian immigrant living in Los Angeles by the name of John Dopyera. Beauchamp had already seen an "ampliphonic" violin (basically a violin with a phonograph-style horn attached) and wanted to show it to Dopyera. But Dopyera was already cognizant of the need for a louder guitar. The urge to take an instrument of historical intimacy and make it loud was an idea waiting to be born. Various Heath Robinson efforts with the horns and discs of Victrolas had already been tried but with feeble results. Nevertheless, the inexorable march forward to the era of Jimi Hendrix and Led Zeppelin had begun.

In Taft, California, Dopyera came up with the idea of the resonator, partly derived from the earlier phonograph idea and partly re-invented. It was a breakthrough in guitar design. The resonator was basically a wafer-thin, conical-shaped disc and attached to a cast-aluminum bridge. And it worked beautifully. John Dopyera and his brothers then struggled with improvised dies and lathes to bring the resonator guitar into production. His prototype "tricone" guitar was distinctive for many reasons, most conspicuously in that it was made not of wood but of an alloy known as German silver. It was fitted with an aluminum T-shaped bridge mounted over the cones in the body; it transmitted the vibrations of the strings to the three diaphragms and gave a loud and distinctive tone. With a sound flowing like a river, as John Dopyera put it, the resonator guitar was born. They called it the National.

The National appeared on the guitar market in the 1920s as a radical new technology, and became an instant success. Shortly thereafter, a Hawaiian guitarist by the name of Sol Hoopi made his debut with his National in a chop suey house in Los Angeles and with it went on to take the world by storm. His popularity was significant in popularizing the instrument. More Hawaiians followed, King Bennie Nawahi, David Kane, Soloman Uki Makekau, and the fabulous Tau Moe family, who took their National to Shanghai and had it copied by a local tinsmith. The silver guitar became ubiquitous. It was the guitar of choice among great blues players like Scrapper Blackwell, Tampa Red, Son House, Bukka White, and Bumble Bee Slim, and country players like Brother Oswald. The shining metal, like a medieval knight's shield, conferred a glamour and attraction that took the player out of the ordinary and into a dimension that became identified with success and musical magic.

Meanwhile, back in Los Angeles trouble was a-brewin'. John Dopyera and his three brothers had originally formed the National guitar company with George Beauchamp, but there was great friction between the Dopyera brothers and Beauchamp, so they left and formed another company known as Dobro, which is a contraction of "Dopyera" and "brothers" (*dopyera* means "good" in Czech). They redesigned their resonator guitar, making it out of wood this time, which is the principal difference between a Dobro and a National. Also, the resonator is convex rather than concave. The cognoscenti consider the National to be the pre-eminent resonator guitar, particularly the models built in the twenties. John Dopyera himself always considered the Dobro inferior to his original National Tricone.

A few years later, after lawsuits and more fighting, the Dopyeras got the best of both worlds when they re-united with National, and became the National Dobro Guitar Company. Despite these interminable disruptive frictions, several new models of resonator guitars came into existence including the Triolian, Duolian, single and triple resonator guitars, and the El Trovador Estrallita Aragon.

Since the 1920s, the National has continued to play a unique and important role in the history of American guitar music. The sound of silver rolls on across the continent like an endless ripple. And as John Dopyera put it after making his first tricone, "it flows like a river."

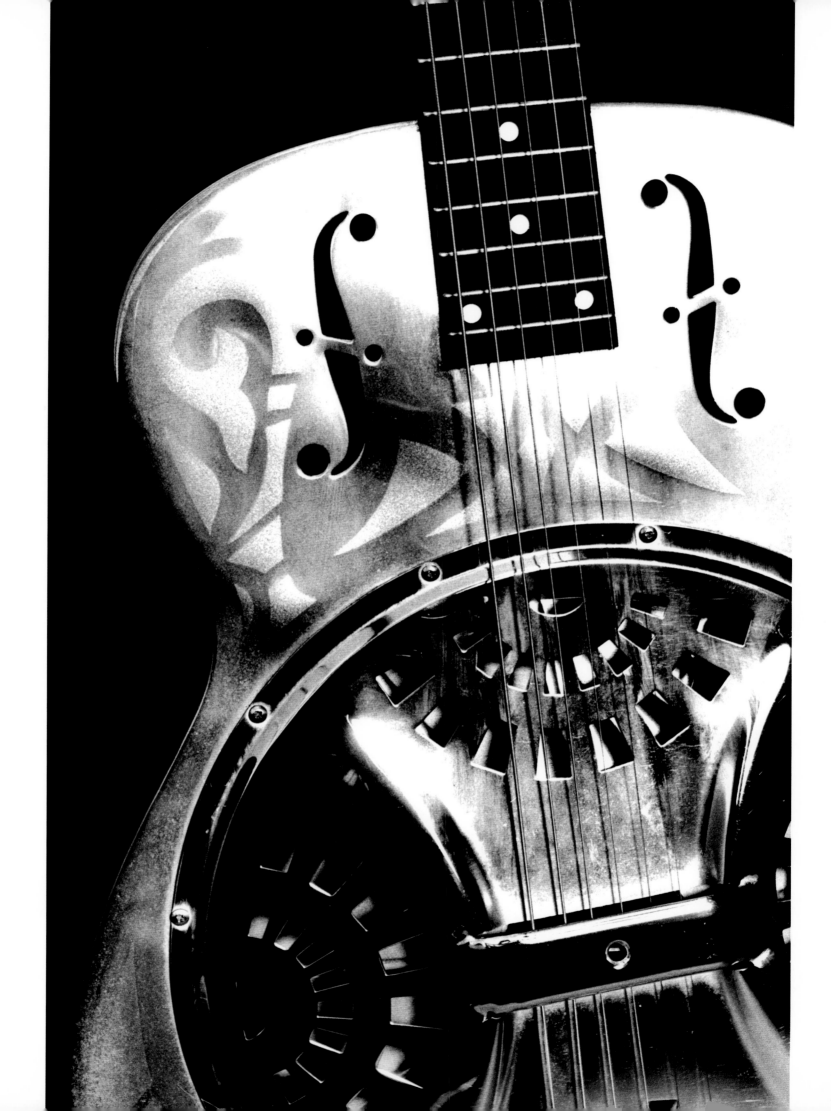

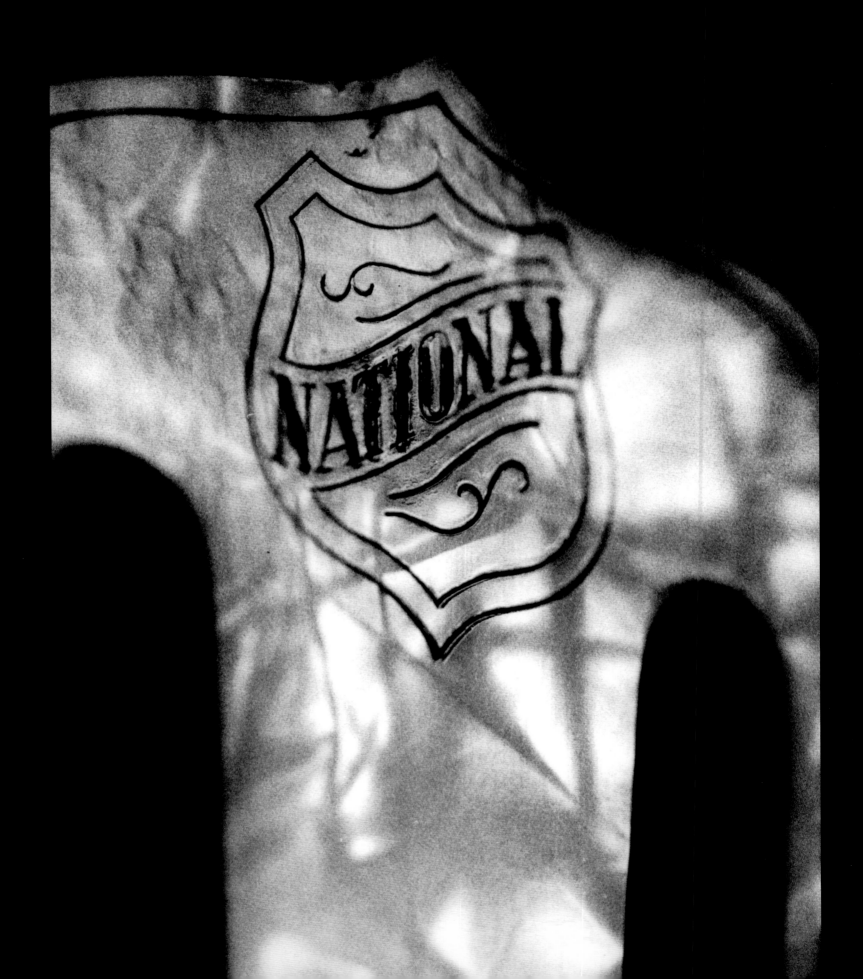

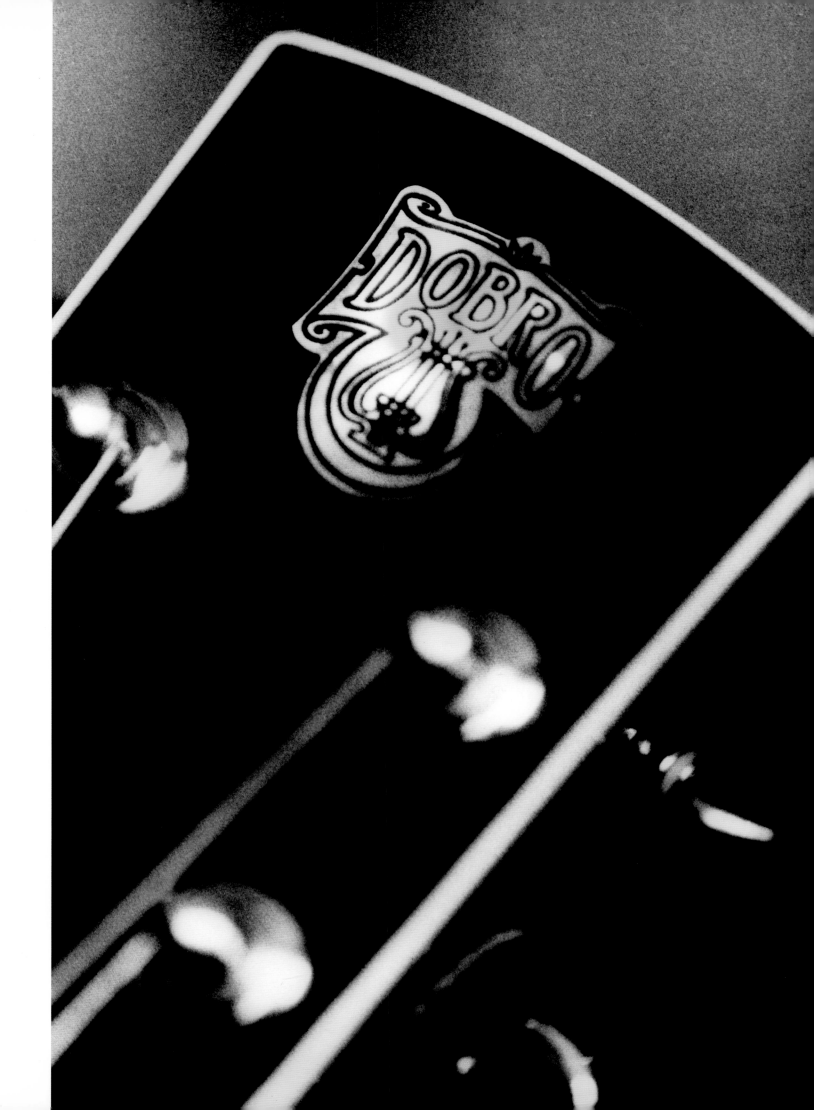

NATIONAL
STRING INSTRUMENTS

The Pick resides between the index finger and the thumb and shifts shapes and materials and textures in a search for the perfect wedding between the clenched hand and the vibrating string.

SHAPES—pear heart oblong triangle fan ice cream cone oval teardrop curve trapezoid diamond arrowhead rectangle broken heart

MATERIALS—ebony ivory plastic stone silver celluloid ostrich feather eagle feather raven feather fiber bone coconut casein tortoise shell nylon gorilla snot rosin cherry bark acetate acrylic bronze agate

CORRUGATIONS—cork rings pads center holes plugs rubber cushions grommets crescent moiré spadecork crosshatch

SUBSTITUTES—credit cards coins paperclips pens nails bottle tops fingernails single finger grips

ARCHITECTS—Ancient Egyptians ancient Chinese the Moors Carolyn M. Cochrane Frederick Wahl Aaron Burdwise Richard Carpenter Thomas Towner Luigi D'Andrea Jim Dunlop Joseph Moshay John Pearse Shojii Nakano

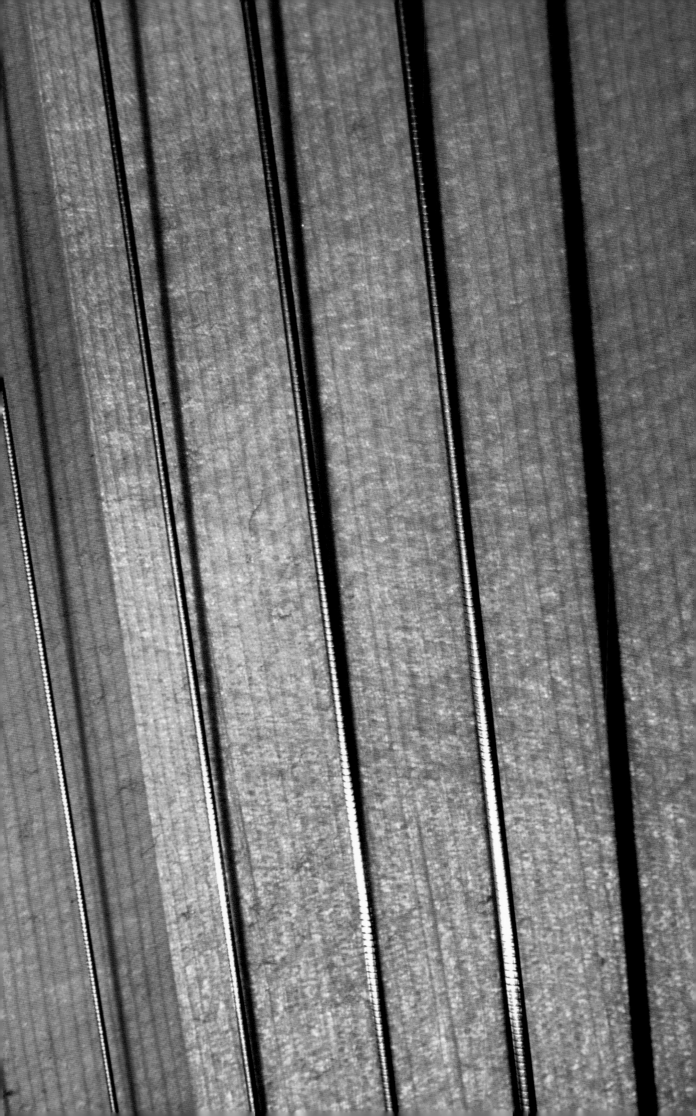

The string has a history. A length of gut ripped from the carcass of an animal, twisted and stretched between two points of green willow. It vibrated, danced, had tension and a sound that penetrated body, mind, and soul. The archer and the string converged and music was born. The string was the bringer of death and the mother of music. Ear, hand, string, sound, tension, and note became signatures of survival, and sang how well it would work or kill.

Dried and stretched, the gut vibrates and dances over shells, skins, and wood . . . a voice from elsewhere. It travels in the company of men through forest, cave, wood, and fire, singing its song of the ineffable. Pythagoras conceived the universe to be an immense monochord, with a single string stretched between heaven and Earth. Pythagoras revered the stringed instrument above all others and advised students to avoid listening to cymbals or flutes and their deleterious noise. He stretched the string between pegs and divided it in half. This gave him the octave. He created further divisions, found other intervals, other ratios. Music was discovered to be an exact science, and from his experiments with the string, Pythagoras evolved mathematics, harmonic ratios, and the Music of the Spheres.

The strings traverse the guitar from west to east, along the length of its body from the tailpiece at the lower bout of the body, over the bridge, and down the neck to disappear through the mouths of the tuning pegs. There is a string science of breaking load, tension, diameter, and material, and the journey to evolution of the modern string is a history of continuous experimentation with these factors.

The modern guitar has six strings. Nearest to the player is the low E, followed in ascending order by A, D, G, B, and E, from thick to thin, tuned in intervals of fourths except for the G and B, which are a third apart. The gauges, or thicknesses, are measured in millimeters in a range from 009 to 056. The guitarist can make his own set by mixing and matching gauges, he can change it, customize it according to the strength of his hands, or for the kind of music that he plays.

The string is music. An indivisible part of human consciousness, it dances down through the time above ivory, bone, wood, and metal. Kithara, lyre, rabat, and guittern—an endless variation of instruments tuning and pairing strings in double and triple courses through the middle ages and into the sixteenth century, until the stringed instrument was ubiquitous. During the Renaissance and into the Baroque, masters of music like Corbetta, Weiss, Sanz, Sor, and Bach wrote

assiduously for the string instrument, and treatise methods, tablature are all precursors traceable even to ultra-contemporary learning methods like video, DVD, and CD ROM. Dionso Aguado commented in his own manual that the guitarist must be a "master of strings." In time, after endless experiment, the six-string guitar is born. In its moment of birth it is controversial because it is an advance on the well-liked Baroque guitar, but it takes hold, grips the imagination, and is perfect.

During the eighteenth century, the six strings were divided into three of gut and three that were bound with silk. The modern guitar string was coming but it was not until the turn of the twentieth century and the need for a louder guitar that steel-string manufacturing got under way.

At the advent of the twentieth century, string making was in its infancy; there were problems with corrosion, tarnish, and the ability of the string to survive the stresses of playing. The early Gibson steels were made from silver-plated copper wire for the treble strings and silver-plated copper wire wound in silk for the three bass strings. Unfortunately, they broke all too often and lacked power. The experiments continued. In the late 1920s, the company tried a gold alloy wrap, but it was too soft. Then came Monel, a special alloy that was ultra-strong and similar to stainless steel. These were the Gibson Mastertone Deluxe strings.

The technology advanced. The inner-core wire was thickened, the outer was made smaller, loops were added to hold the string in place. New materials became available—silver wound on silk, bronze wound on steel, hand-polished silver steel, hexagonal wire for a better grip on the winding—as well as new formulas for improvements like anti-tarnishing on-line polishing. Today string making is controlled by computers in humidity-controlled environments. The string has become strong, flexible, smooth, and fast. It can withstand abuse, bend and twist with the zeitgeist, express rage, unrest, and the questions of disaffected youth. Strings are the heart of the guitar. Together they hold an almost occult power that has cast a spell for centuries. The poet Lorca compared the image of the guitar's strings to the great star of the tarantula's web waiting to trap our souls within its black wooden cistern.

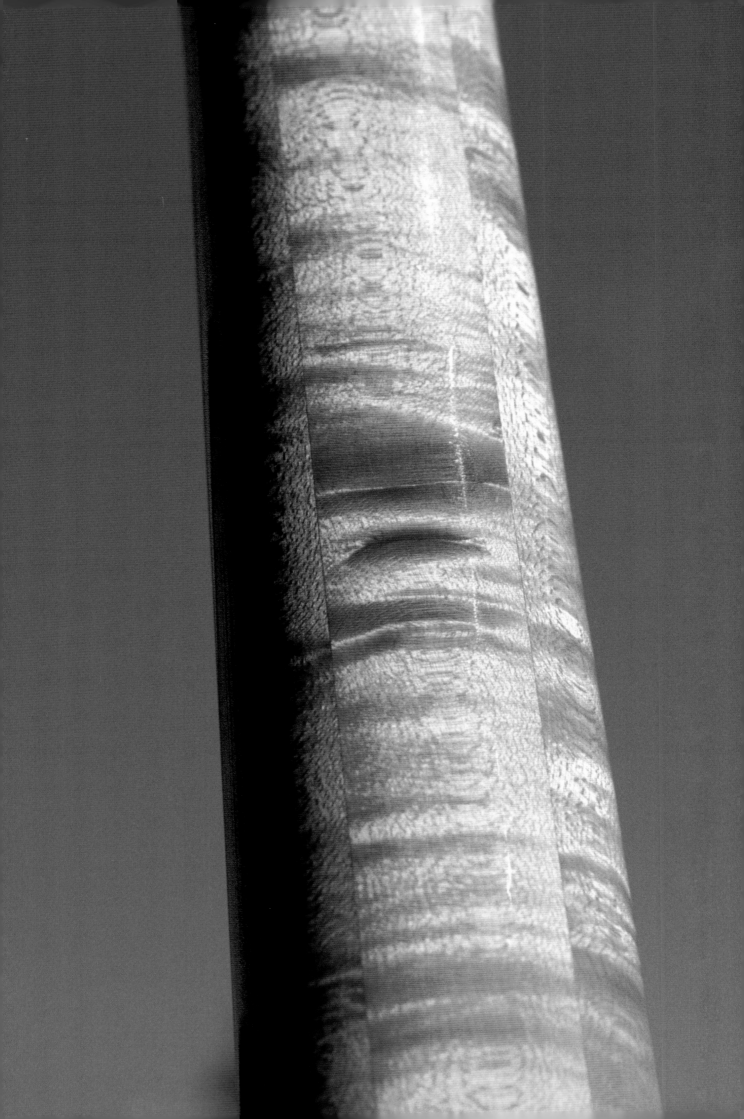

The neck holds the matrix of strings and frets wherein lies the infinite. Implicit with possibility, it is a map, a grid of endless chance, like an Escher painting with its complex of ladders and stairways that circle forever. . . .

The ancient history of the guitar contains a seminal point: that being the moment when strings that previously sounded a single note when suspended between two points of a frame across open space were instead stretched over a neck to yield several notes each in partnership with other strings. Thus from one note per string to several, a giant step was made toward the guitar. The arrival of the neck was accompanied by new challenges: for one thing, how should the divisions be created along the fingerboard? The theories of Pythagoras were important in creating the subdivisions known as the "scale of nature," or the harmonic series. Pythagoras had worked out the appropriate pitch intervals for all the notes in the scales based on the "perfect" intervals that he perceived as harmonics occurring in a plucked string. This, however, raised another problem: how to reconcile the natural scale with the arbitrarily conceived diatonic scale? Pythagoras devised a way to make adjustments in pitch, which came to be known as the Pythagorean comma, and this was an early attempt at a musical phenomenon called tempering.

The idea of the tempered scale was and remains complex and controversial because it involves the ear and the subjective perception of what is in tune. The pure intervals of the original harmonic series begin to sound out of tune as they are transferred from one key to another. Over the centuries, musicians learned to retune their instruments slightly to each new key, a practice that to some extent continues with guitarists of the present day. The controversy over tuning raged from the thirteenth to the sixteenth centuries and involved state, church, many philosophical treatises, as well as bitter feuds, the point being whether or not the original scale of nature should remain inviolate, as it was the handiwork of God. Meanwhile, no one could get in tune unless they surreptitiously adjusted their

instrument. But with the creeping into existence of the modern tempered piano and the composing of *The Well Tempered Clavier* by J. S. Bach, theology and science parted ways and tempered tuning was accepted. Arguments still simmered, but the collective ear gradually accommodated this change and thus a new era was born.

During the few hundred years that this debate persisted, the Lutenists, Bandorists, Vihuelists, etc. were not having such a bad time of it because the frets of their instruments were generally made from gut and were tied to the neck, thus making them movable which gave the string instrument player a distinct advantage over the keyboard player. Early gut strings and the movable fret presented their own inherent problems of tuning, though; the strings were lumpy and uneven, and the frets could move when you didn't want them to. With the advent of sulphur-treated gut and overspun bass strings, the tied-on fret itself became obsolete, making way for the hammered-in steel fret. This method of fretting was universally adopted by guitar makers in the early 1800s.

There is a science to the division of the fingerboard that is known as the Rule of Eighteen which was derived in 1591 by Vicenzo Gallilei after studying the texts of Pythagoras. Simply put, the scale length divided by 17.817 equals the distance from the nut to the center of the first fret; the remainder of the scale length divided by 17.817 equals the distance from the center of the first fret to the center of the second fret and so on. Any instrument that has fixed notes, like a guitar or piano, must have its notes laid out on a mathematical basis that gives an approximate tuneness to every key, or fret; this is known as "equal temperament." Interestingly, with the guitar when using the Rule of Eighteen the notes will play progressively flatter up the fingerboard. This flattening effect, which helps to counteract the natural sharpening of the string when pressed to a fret, provides a simple form of internal compensation to the scale and kept the Rule of Eighteen in use for several centuries.

The neck shape subdivides into three elements. The shaft taper, which is the progressive decreasing of the shaft thickness from the heel to the headpiece; the apex, the area running like a spine along the underside of the shaft; and the shoulders, which are the long portions of the shaft that are located between, and converge with, the apex and the edge of the fingerboard. These subdivisions are infinitely adjustable but are critical because the neck is the essential point of contact between the guitarist and his instrument. The feel of the wood and the shape of the neck are crucial to the player's comfort. In essence it is a sensual experience, which explains why reactions to the contour of the neck are usually expressed as if the guitarist was talking about a lover rather than a carved piece of wood.

In modern times the neck has been more or less perfected. The classical guitar neck, with its extra width and its cross section of an oval, was brought into focus by Antonio Torres in 1850 and remains in favor with classical guitarists today. In the 1920s in response to the growing demand for ever-louder guitars and the resulting increased tension on the neck, the truss rod was invented. The truss rod is a piece of steel that runs through the center of the neck to provide perfect string-to-neck tension for guitars with steel strings, and alleviates the risk of cracking and breaking caused by increased tension. Around the same time, in response to the demands of the jazz players who were beginning to crowd the guitar world, Martin began making guitars with necks that joined the body at the fourteenth fret rather than the twelfth.

Mexico, Central America, Colombia, and Venezuela grow the Honduras mahogany, which is ideal for necks because of its qualities of stability and excellent strength-to-weight ratio. Also easy to work with, it has become the standard material for the guitar neck. Occasionally, when strength and stiffness are a concern, rock maple is used.

The neck is the point of contact and the bed upon which lies the fingerboard upon which dances the music of time. . . .

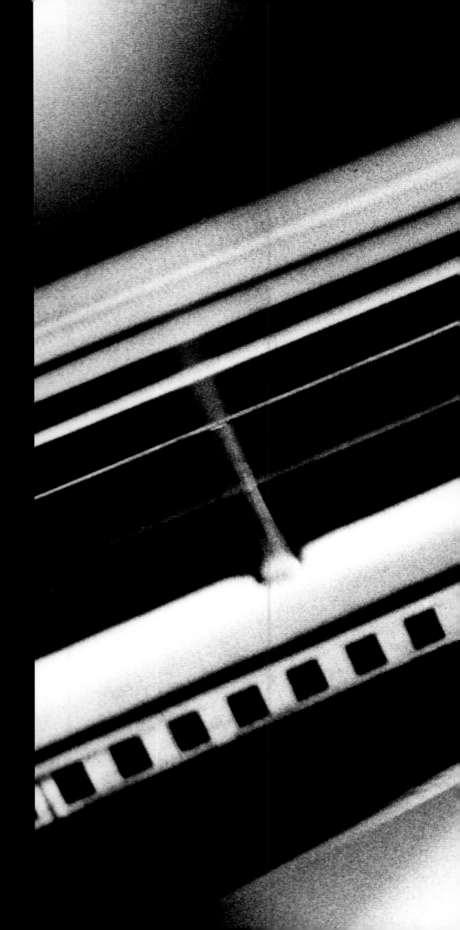

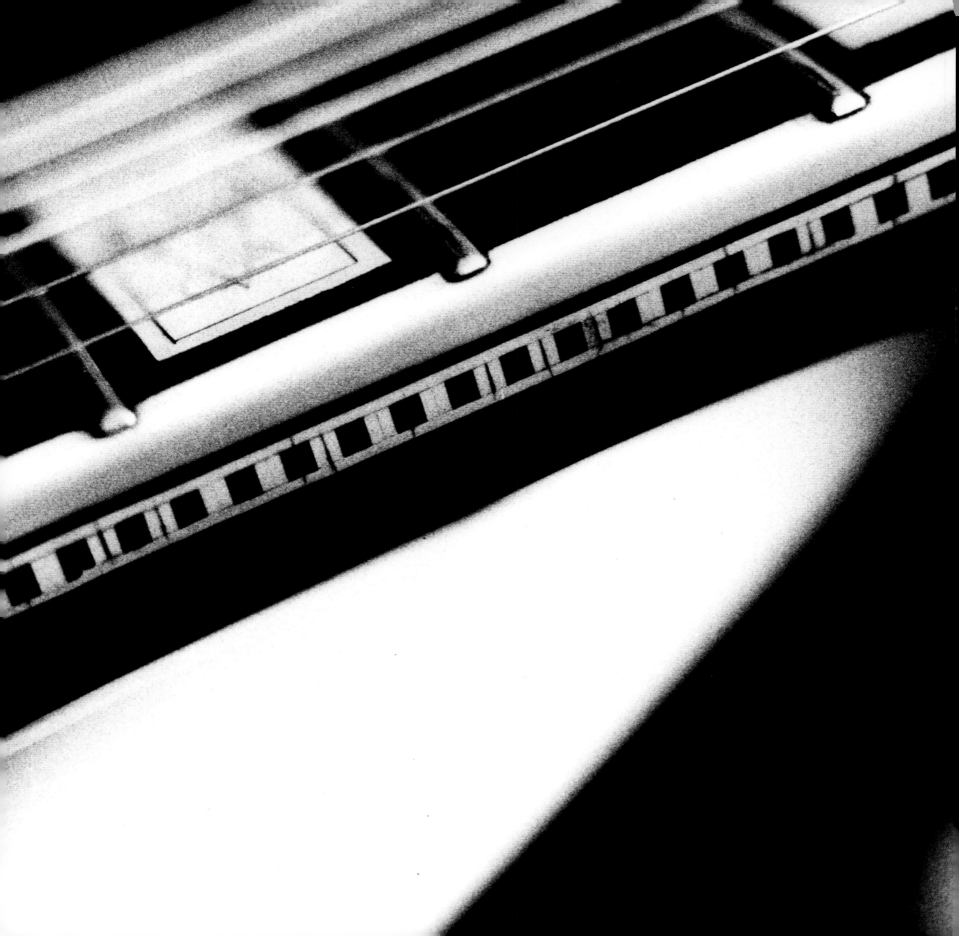

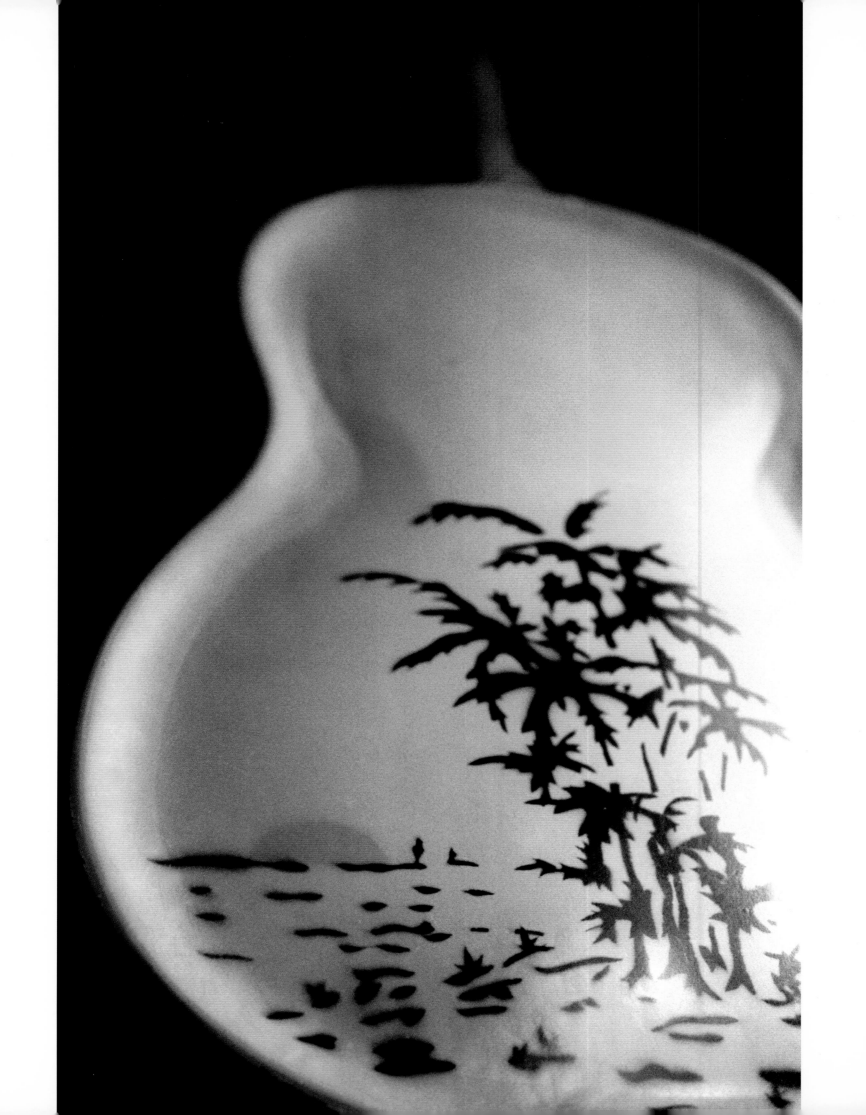

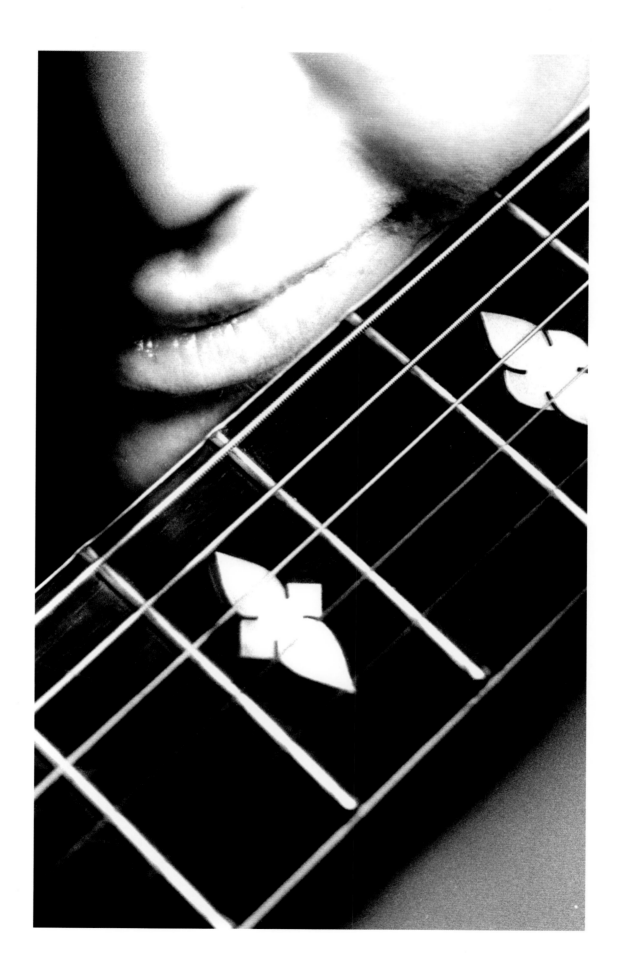

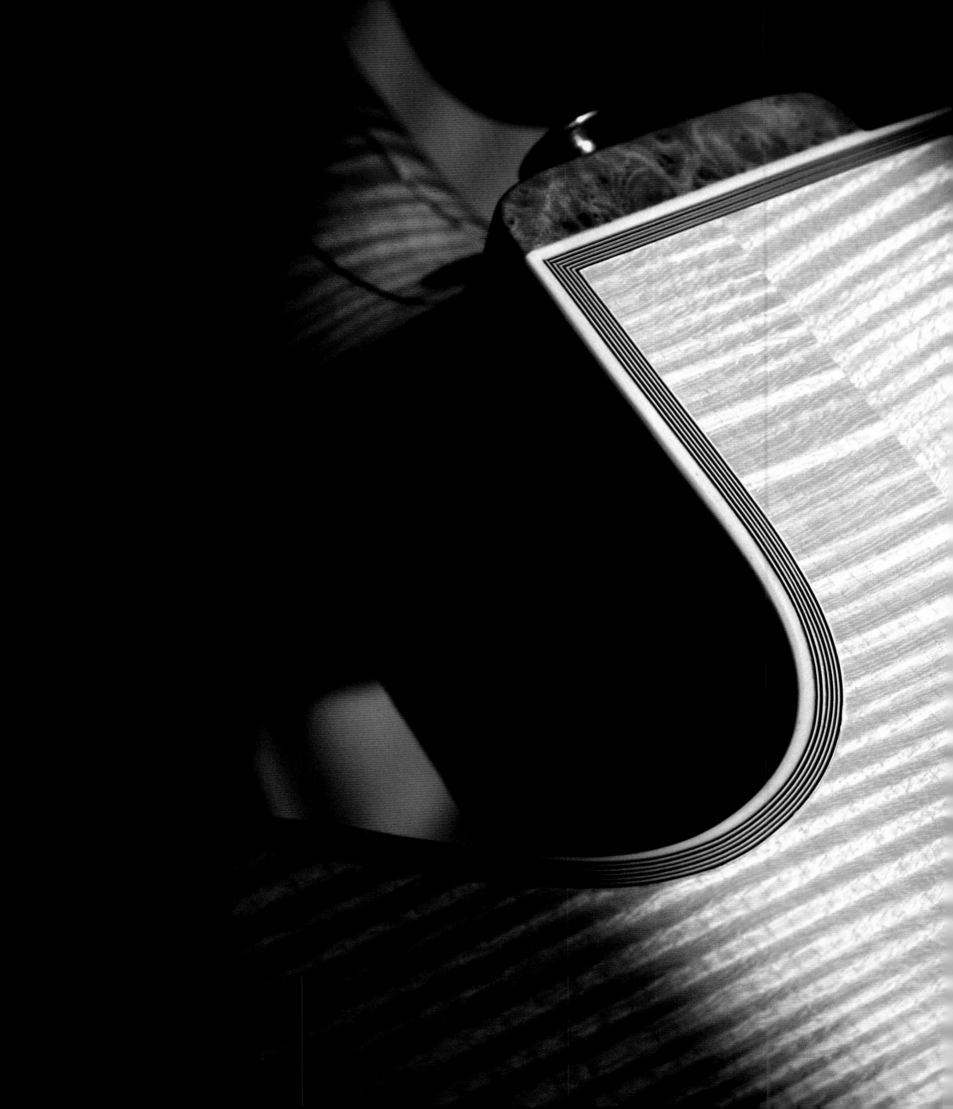

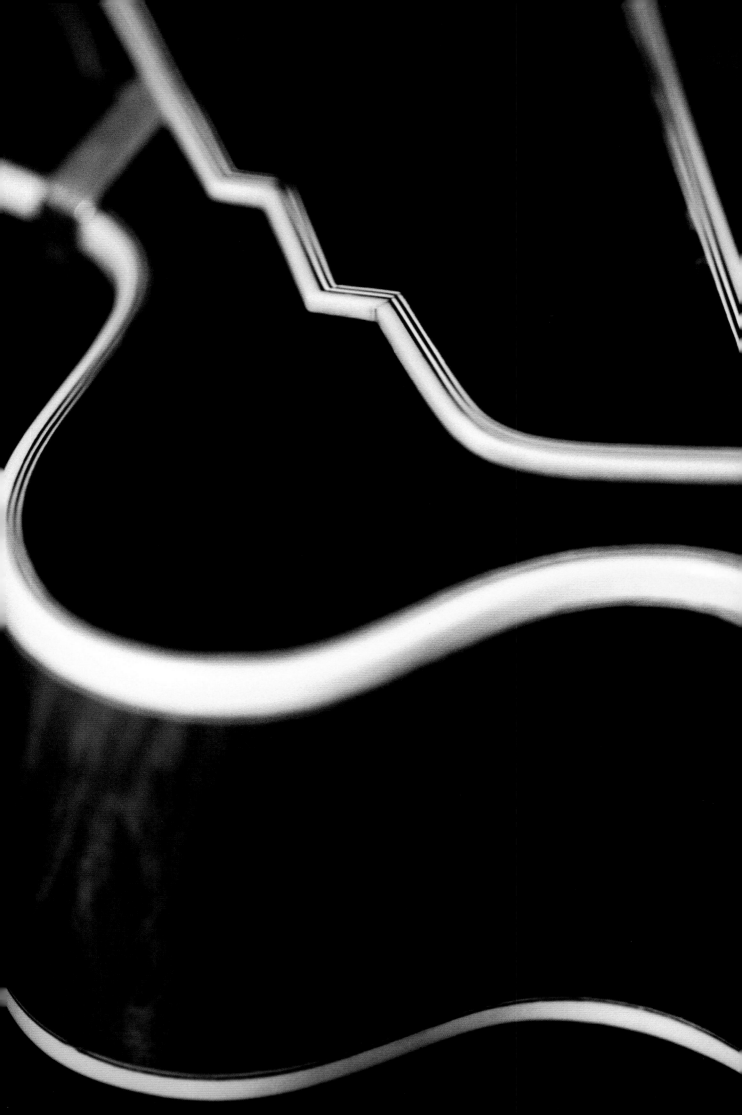

During the 1930s, an incredible new guitarist became known to the world, a Belgian gypsy named Django Reinhardt. Because of a terrible accident, his left hand had only two usable fingers, but with improvised runs of dazzling speed, solo cadenzas, and chordal passages of startling originality and fire, Reinhardt commanded a virtuosity that had never been heard before. The guitar he favored was the Maccaferri, which ever since has been associated with him and the music that is known as Gypsy Jazz. The guitar and the music are synonymous.

Mario Maccaferri was born in Bologna and was a virtuoso classical guitarist as well as a luthier. He accepted an invitation in 1930 to build a guitar for Selmer, a Paris-based company, their one requirement that it be a steel-string instrument to meet the louder volume desired by jazz players. Although Mario was not a lover of jazz, he came up with a visionary design. To obtain the powerful cutting tone that he thought necessary, he borrowed from mandolin construction and slightly bent the top of his soundboard, which featured a distinctive D-shaped soundhole.

Django Reinhardt and Mario Maccaferri —Deux Grand Seigneurs.

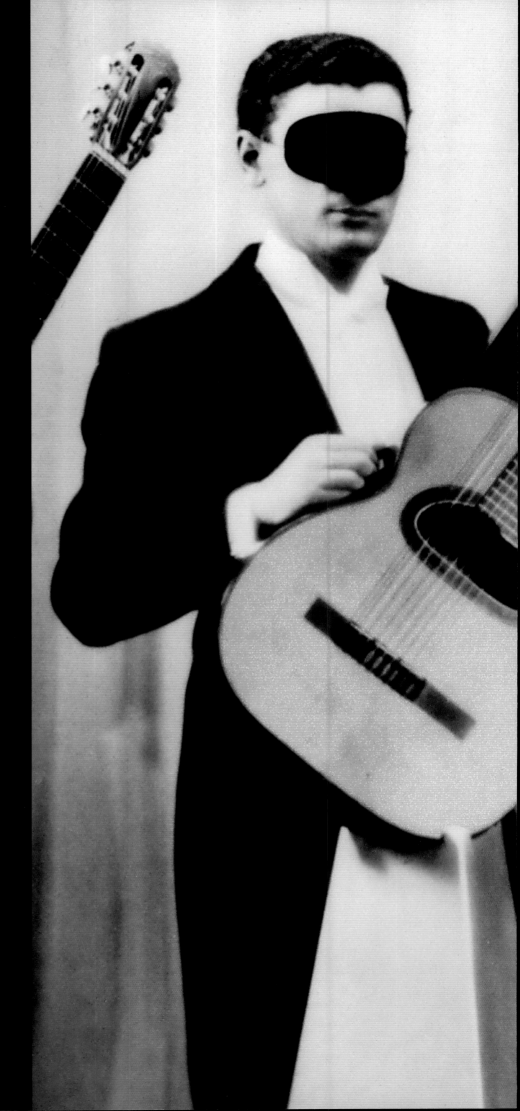

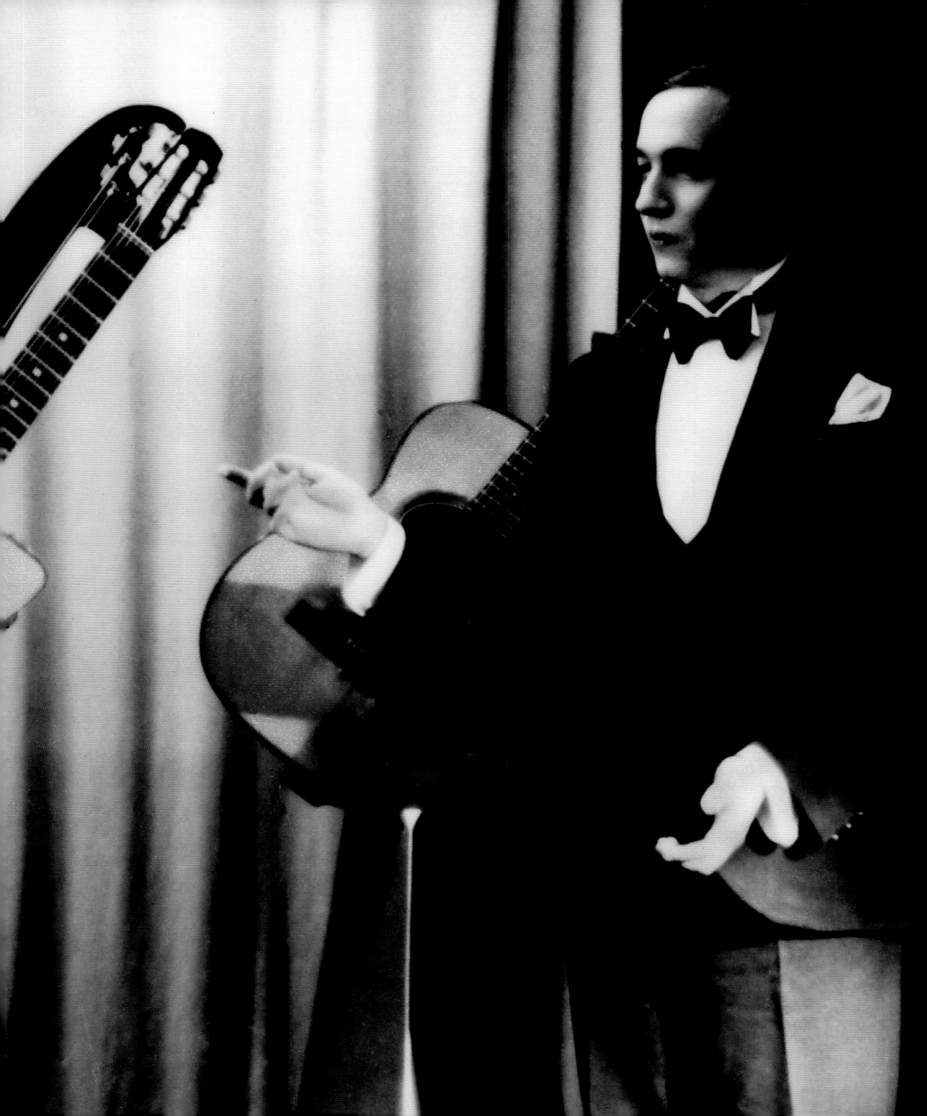

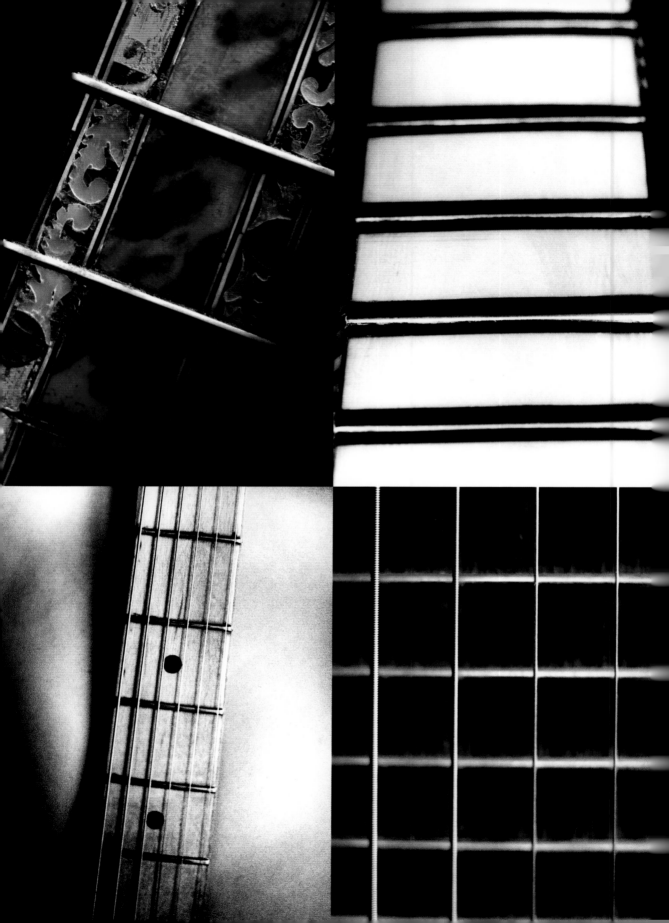

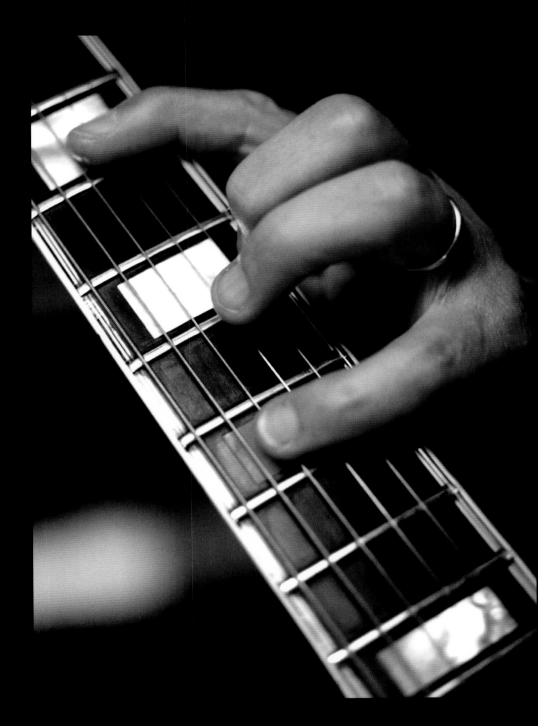

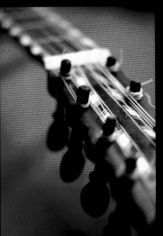

***Ferrete:* banded with iron.** The frets stretch away below the player's hand and eye in diminishing perspective, a grid of infinite geometries where strings and frets converge to create the impossible labyrinth.

Theseus in the maze, trying to slay the Minotaur; the string of Ariadne his only way back to the light. The guitarist improvises a path across the maze of endless crossings that defend the center, wherein lies the divine inscrutable.

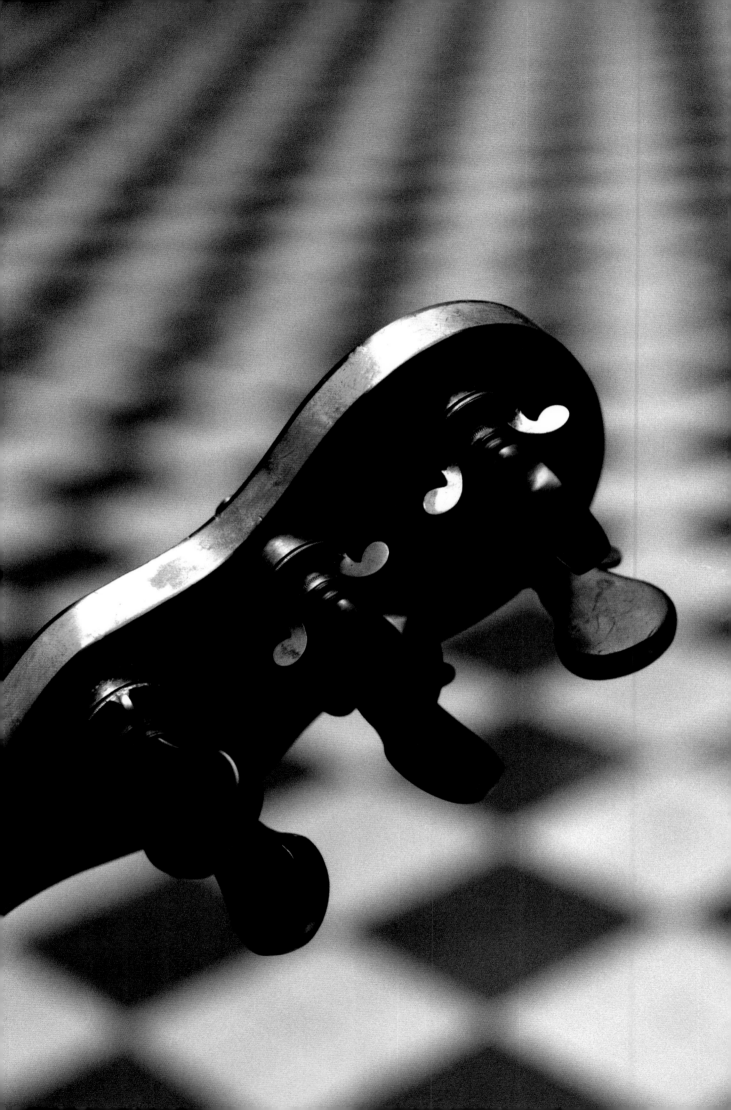

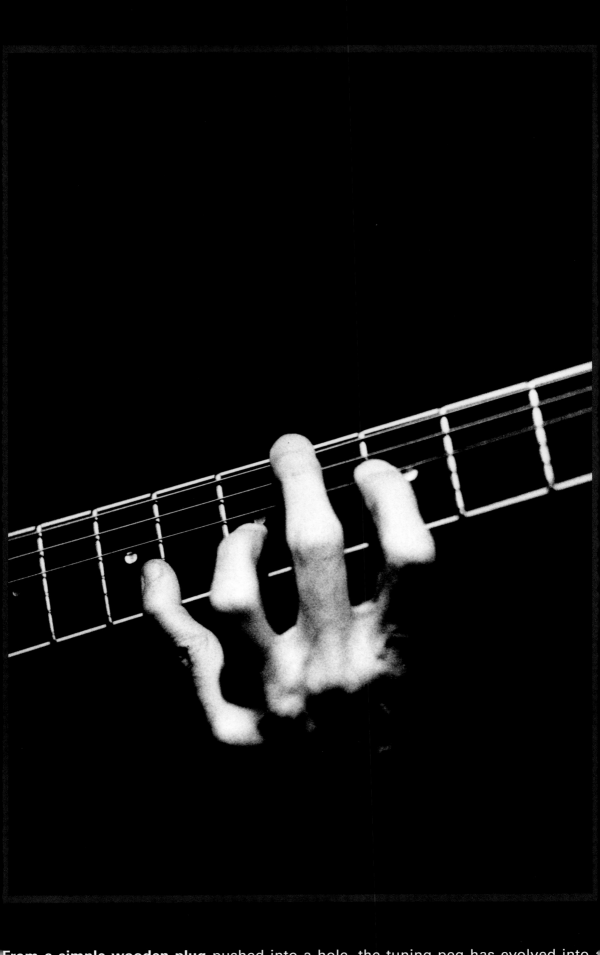

From a simple wooden plug pushed into a hole, the tuning peg has evolved into a precision-engineered screw thread in tempered steel and brass. It pulls the string into precise pitch in infinite increments. Archimedes sits in the headstock.

The quest to find a voice or signature sound, tone, or tone color may be one of the more elusive qualities for which the guitarist strives. On the electric guitar, for instance, he has at his disposal many resources such as pickups, amplifier, strings, body shape, etc., all of which can be employed in the search for a good tone.

The classical guitarist has to deal with touch, hand position, and the ratio between nail and flesh when he plucks the string. And he must somehow navigate his way through this matrix to arrive at a sound that is personal and worthy of being called a tone. What is a "good" tone? There is no single definition because it may be according to individual taste, and possibly appealing to no one but the player himself. But in general terms, it may be defined as a sound that has character, authority, and a quality that reflects the player. Technically it might be said that a tone is a sound that consists not only of its fundamental root but also a series of overtones that hover above it like sonic shadows . . . the octave, the fifth, the third, sixth, ninth, eleventh, disappearing upward like a ladder into heaven. It is these and their prominence, or lack thereof, that lend harmonic richness and character to an instrument.

The legendary guitarists have all been the possessors of great tone. In jazz the great Jimmy Raney played a Gibson ES-150 and created a tone that perfectly matched the turns and spirals of his lines. His phrasing, some of the most poignant in jazz history, influenced Miles Davis. Wes Montgomery, who played incredible lines with his thumb only, extracted a warm, personal sound from his Gibson.

It was a tone that was human and soulful. Kenny Burrell played with a liquid and bluesy touch. The

dark, mournful tone of his guitar seems to say. "I am the night."

In the sixties, Eric Clapton took his cue from BB King and Buddy Guy and opened up the parameters of electric guitar by pushing his Les Paul through an amp cranked to maximum, which created a full, wet sustain known as the sobbing woman sound, a tone that has essentially been the sound of rock guitar ever since. Jimi Hendrix practically reinvented the guitar when he arrived on the scene, turning his Stratocaster into a howling, raging feedback machine, dialing up what seemed like a never-ending rainbow of guitar color.

The classical guitar maestro Andres Segovia played his Hauser or Ramirez with a silvery, liquid voice that brought a deeply romantic sound to all of the music that he played. His sound has been emulated but never matched. In the recording of his transcendent performances of the Bach Chaconne, Segovia's tonal vibrato sinks into the variations with an emotional depth that still cuts to the core more than fifty years later. During the 1920s and '30s, a Paraguayan guitar genius, Agustín Barrios, played his fantastic classical compositions on a steel-string guitar with an elastic band wrapped around the nut to soften the steel tone, which when heard is poetic enough to be compared to the sun moving out from behind a rain cloud. From the late 1950s onward, Julian Bream brought masterful interpretive power and tonal color to the classical guitar, and more or less single-handedly brought about the second renaissance of classical guitar.

Django Reinhardt and the Maccaferri guitar are inseparable; the peculiar construction of the Maccaferri and the unique genius of Django became the sound of

Gypsy Jazz, and although he only had the use of two fingers on his left hand, Reinhardt got a hot, sweet trumpet-like tone from his guitar that will forever be associated with that music.

The list of great players is long, but most of them are distinguished by a remarkable tone.

How is it achieved, this voice that cuts like a knife to the heart, finds an echo in the soul? How are seemingly inert materials brought to life and given voice, emotional power? It might be imagined that perhaps the origins of tone are in the mind, that tone begins as a sound in the head, a voice that is recognized as if in a dream; or it might be simply that the student begins to recognize something in another player's sound and desires to make that sound himself. However the seed of awareness is planted, the player's hands may now seem to collude in a new way. Small adjustments are made, the position of the hand shifts, the treble tone control is backed off, a little distortion is added, and the tone begins to match what the player hears in his imagination. . . .

Tone is a statement. It is personal and speaks of the player in a way that no configuration of notes or harmony can. It stands alone. To describe tone with words is ultimately useless, for it is elusive. It must be heard/felt. Tone is soul, emotion. It is the heart speaking; the angels sigh within us.

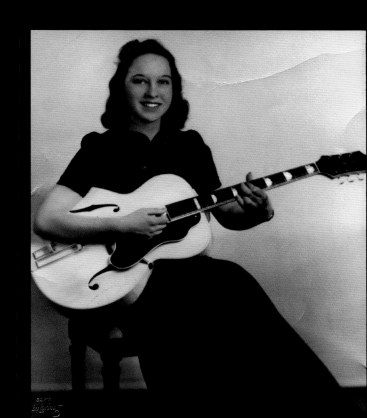

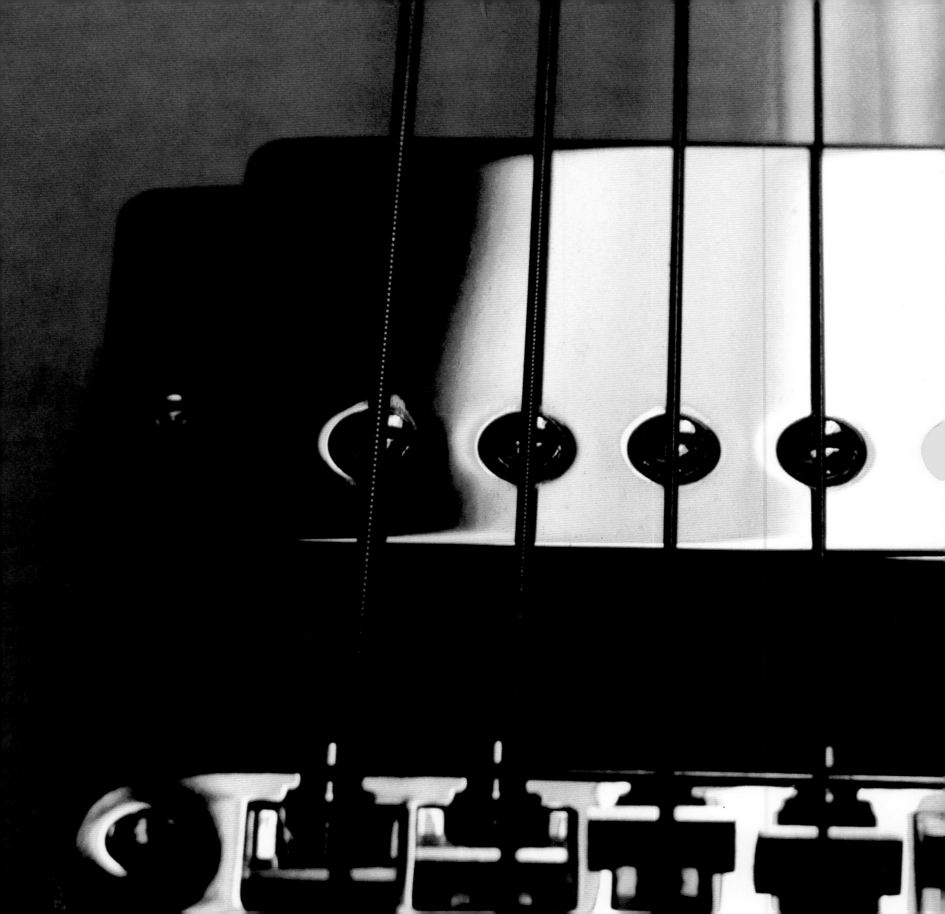

Power radiates like a sun from the center of the electric guitar. The player strikes and the vibration of the string moves through the magnetic field of the pickup to generate an electric current in the coil, which gives birth to the signal that races down the umbilical tunnel of the guitar cable to greet the world with a howl through the amplifier. Like a bird, or a magician, the guitarist's hand moves over the humbucker, the eyes of the audience upon this sleight of hand as the coils unleash their power. Louder than drums, the sound of the electric guitar symbolizes and shrieks out the voice of youth.

The alchemy of the vibrating string and the magnetic field has produced a song that moved from the gentle emulation of the tenor saxophone in the 1940s to the scream of the disaffected rock generation.

Gibson experimented with electric guitar pickups as early as 1924, but the attempt seemed half-hearted. The acoustic guitars were so beautiful it seemed a profanity to mar them with hardware. They tried something called an electro-static pickup, but it picked up vibrations from the body and the bridge rather than the strings; it was not a great success. But in 1936 the electric guitar came of age with the invention of the bar pickup, which was built into the Gibson ES-150. Before long it was in the hands of the young Charlie Christian, who only two years earlier had started his career as a piano player in Kansas City. He may not have been the first guitarist to record with an electric guitar, but it was his playing and long spinning lines that revolutionized the guitar.

Wood, wire, magnets, and coils that pull from opposing compass points; the electric guitar pickup, simple and crude in origin, has turned the world on its head.

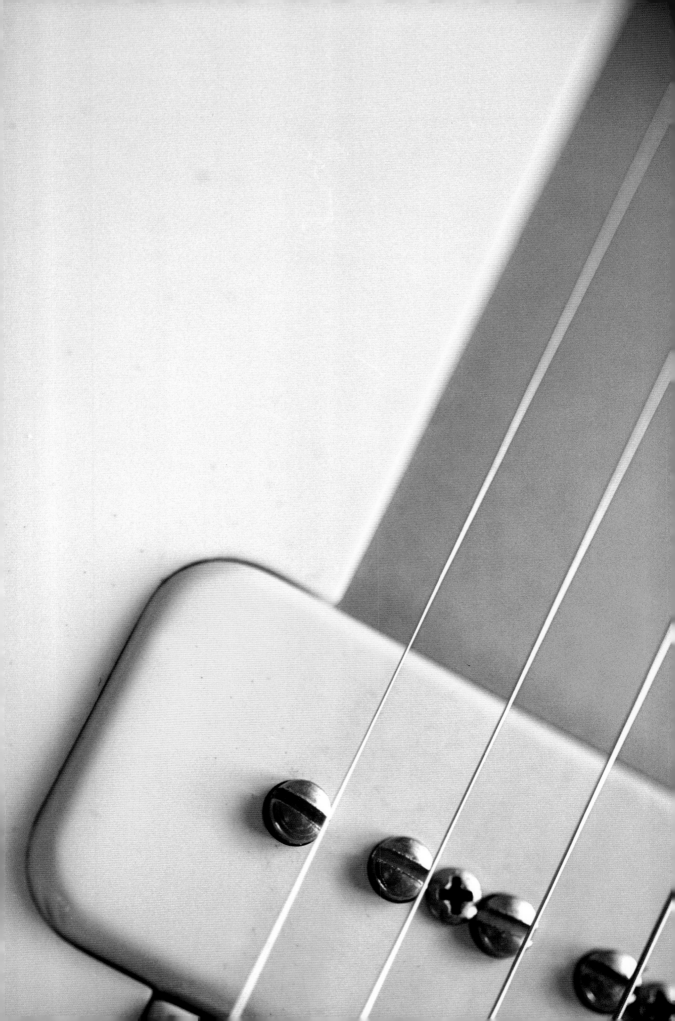

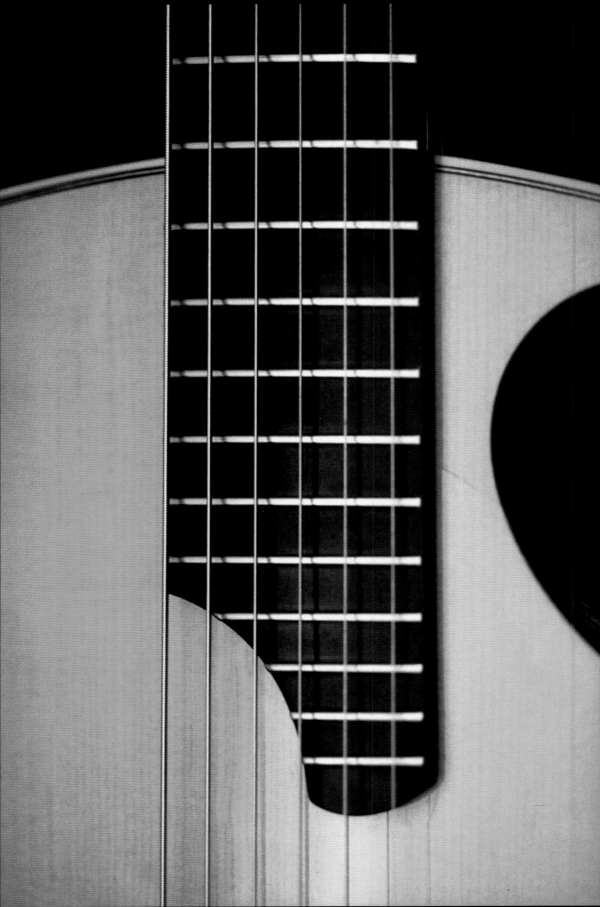

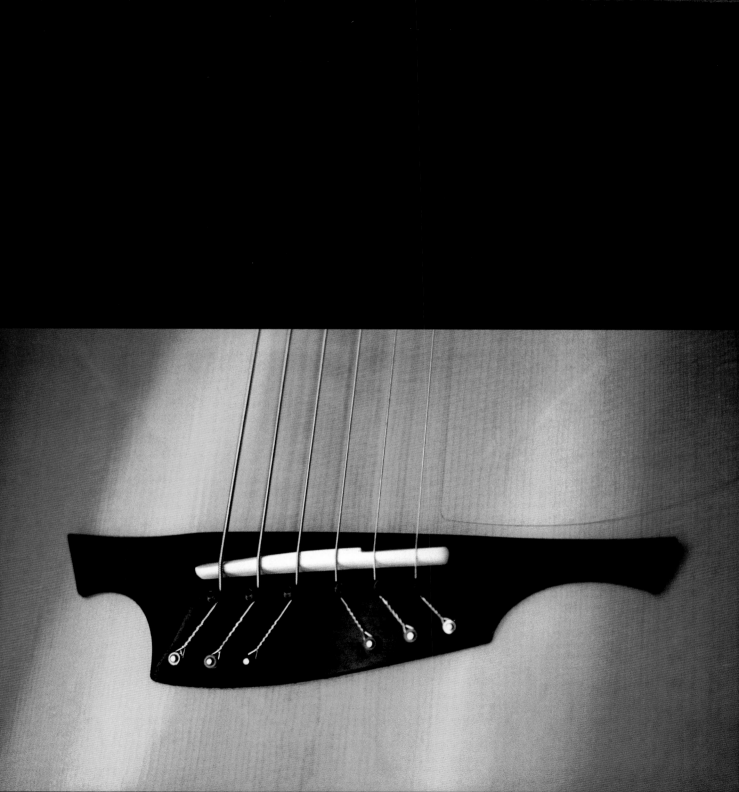

In the history of guitar design, a seminal point was reached with the fan-braced design introduced by Torres in 1860. Since that time, and despite the virtual perfection of Torres' achievement, the guitar has been subject to a number of radical design changes, for it seems with each succeeding generation comes a further urge to extend what we know as the guitar. At the dawn of the twentieth century, with the demand for louder guitars, C.F. Martin began experimenting with steel strings, which had more volume. Martin also invented an X-brace design to hold the increased tension of the new strings. Thus loud guitars were born, and it was not long before an exponential leap was made with the arrival of the electric guitar, which was developed out of the Rickenbacker Hawaiian guitar in the twenties.

With the advent of the electric guitar, the doors for guitar design flew open, and all styles of body and methods of amplification were investigated. As the challenges of guitar design penetrated the modern world, amazingly ingenious ideas surfaced year after year. In the 1940s, an American guitarist by the name of Les Paul started to play around in the Epiphone factory with a solid chunk of wood onto which he'd attached a couple of crude homemade pickups. When asked what it was, Les referred to it as "the Log" or "the Clunker." This was the precursor to the Les Paul guitar, which was to become an icon of the guitar world. At the same time that Les Paul was experimenting with his "log," the idea of another solid-body guitar—the time obviously had come—was being undertaken elsewhere, notably by Leo Fender in California, as well as in the workshops of Rickenbacker and National.

The urge to create unorthodox designs has often been encouraged by the guitar players themselves. One of the areas often experimented with has been stringing. Although Gibson built some beautiful harp guitars early in the twentieth century, the idea goes back much further in time. The chitarra tiorbata, for instance, dates from around 1640. This instrument was built with an extra peg head in order to accommodate several bass strings, along the lines of the theorbo, but because it was difficult to play, it never won general acceptance. Other variants were guitars with two necks, one with three necks and twenty-one strings, and eventually a lyre guitar with two curved arms emanating from the sound box.

Bizarre and eccentric variations abounded in the nineteenth century, among them the enharmonic guitar of the English general T. Perronet Thompson, who published instructions on a microtonal tuning system in which the octave was divided into fifty-three equal parts; so difficult was this that his guitar never materialized into reality. Along similar lines, something called a "guitarpa" was invented by Jose Gallegos in Malaga, a strange mating of a cello, guitar, and harp; this instrument had thirty-five strings.

The late twentieth century has seen continued innovation, with the guitar being wedded to synthesizers; the headstock removed to the tailpiece area of the guitar, à la the Steinberger; strings locked down to accommodate whammy-bar bending; and the carbon-reinforced classical guitars of Greg Smallman. In retrospect, it appears that the guitar archetypes were all in place by 1960, with the invention of the archtop, the steel string, the fan-braced classical, the solid body, and the semisolid. But despite the loaded history of guitar design, makers continue to experiment and search for the ultimate guitar.

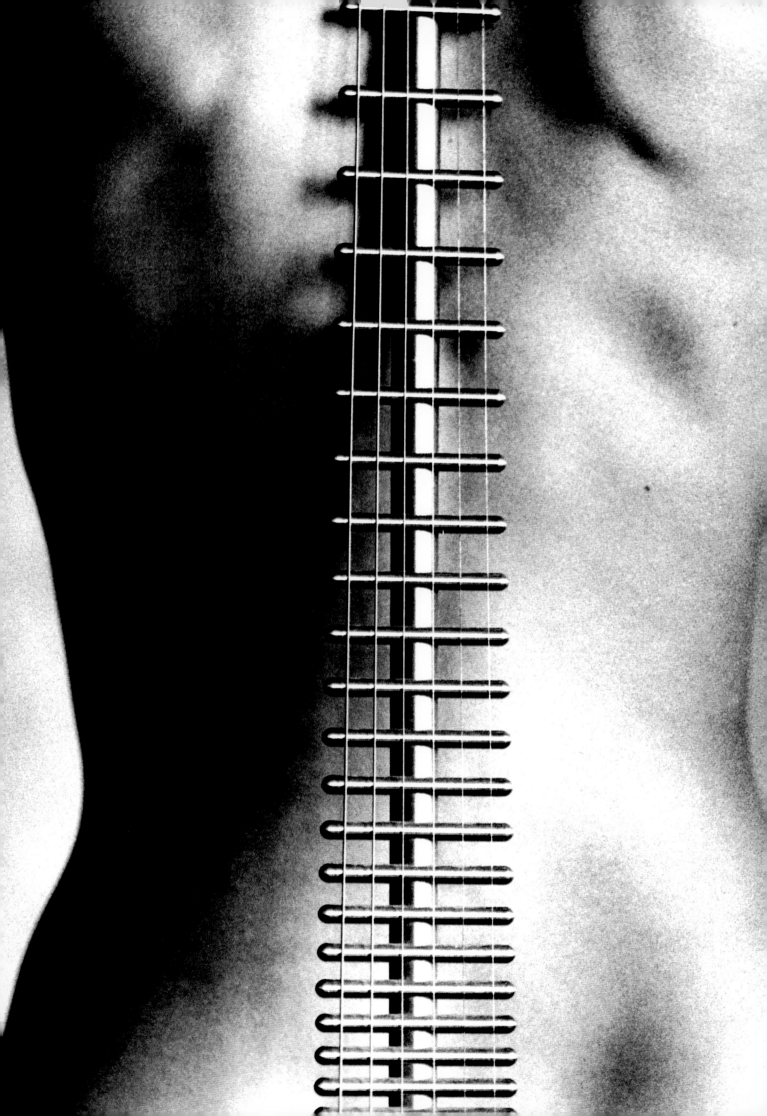

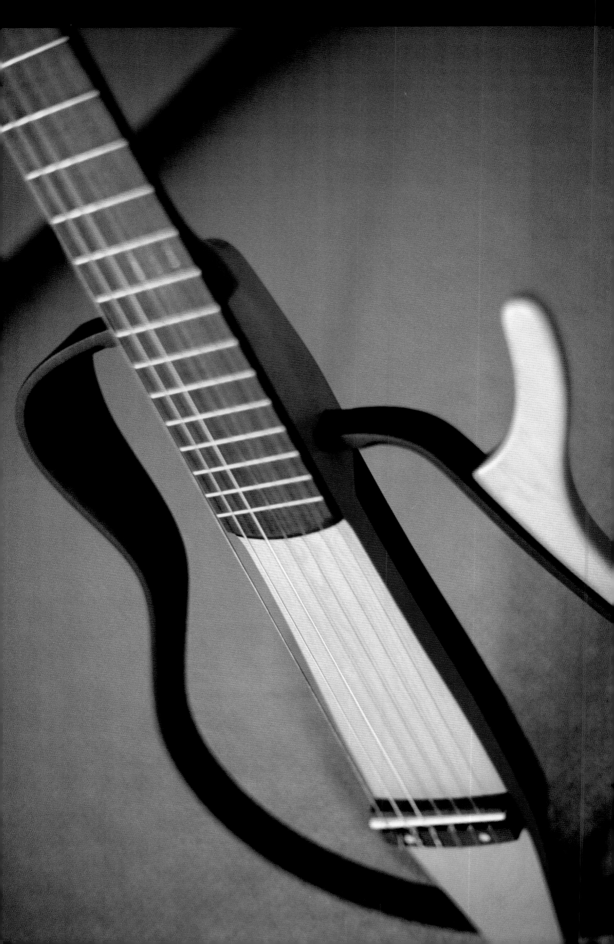

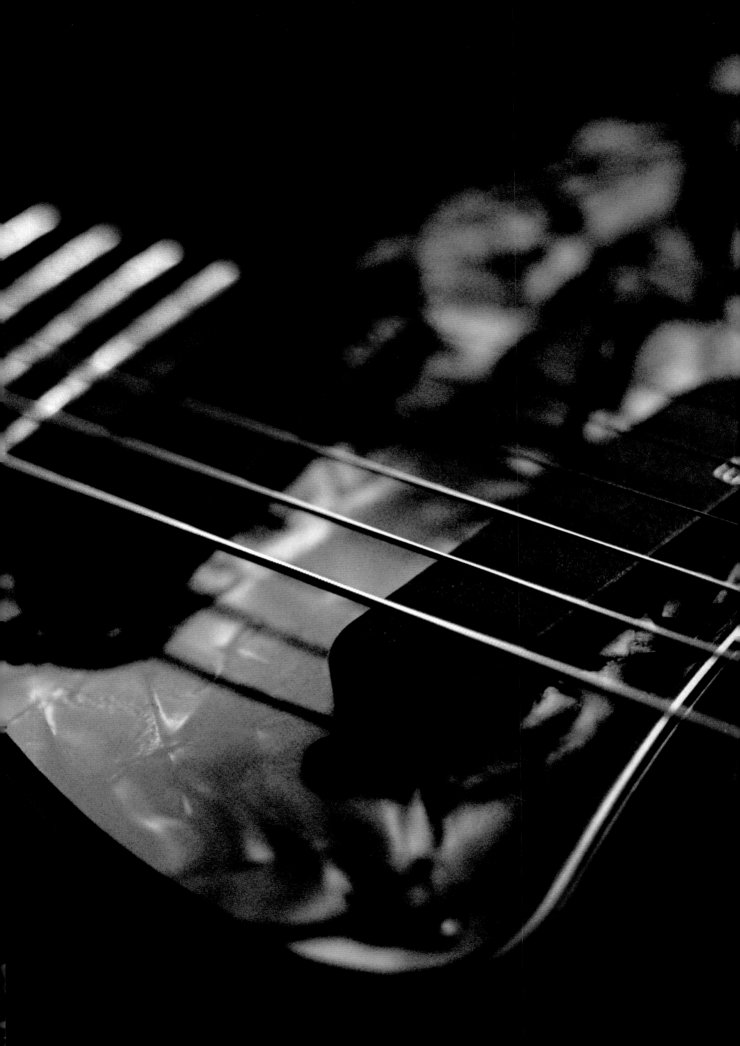

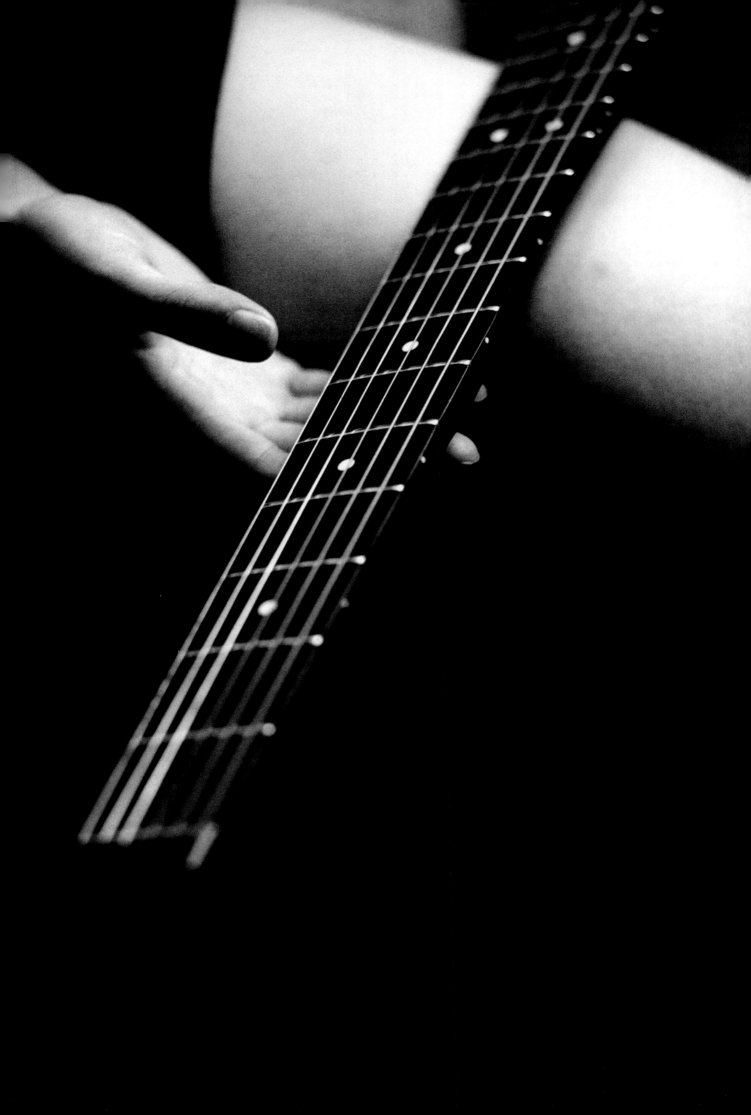

Like the drum, the guitar exists in the psyche as an archetype. Its true origins will probably never really be known, for there seem to be several points in history when a thing with strings might have been a guitar. One archaeological object from somewhere around 1400 B.C., for instance, is painted with a picture of a Hittite musician playing a long-necked instrument with a shape similar to a guitar. It is a known fact that the popular instrument in that part of the world in ancient times was the tanbur, which has a long fretted or marked neck but a bowl-like or pear-shaped body instead of the familiar guitar shape.

For the sake of argument, it might be said that the real history of the guitar began at the point that it assumed the shape of a woman. This point, however, didn't arrive until eons after its beginnings as a hunting bow. Once the twang, the vibration of the string, was established, it became something that apparently humans could not do without. It passed through several early civilizations in one form or another: through Mesopotamia, Chaldea, India, and Assyria, stretched over turtle shell; and then into ancient Greece as the lyre, or kithara, by which time several strings were attached to a small wooden frame, making it more a harp than a guitar. An evolutionary step was taken when the idea of the fingerboard was born; then several notes could be obtained from one string, which replaced the need for several strings, as with lyres and harps. This represented a major technological breakthrough for the time.

The derivation of the word *guitar* is from two Persian words, *tar,* which means string, and *char,* meaning four—thus *chartar,* a four-stringed instrument.

By the time of the medieval period, the guitar was known in Europe and was noted in the literature of the time: in the French romance *Blanchefleur et Florence,* written around A.D. 1200, and again by Chaucer, who mentions it in *The Pardoner's Tale,* as he describes young people dancing to the music of the "gyterne". The guitar shape, with its female curves, was fairly common by this time, and the light romantic instrument found favor with women. The fact remains that the female form perfectly suits an instrument made to be held close to the body.

Throughout the Middle Ages, a wide variety of plucked instruments proliferated, but like wheat being sorted from chaff, the dawn of the sixteenth century saw many of them disappear while others, like the lute, vihuela, and rabat, gained universal acceptance.

The vihuela was the leading instrument during the Renaissance. The term *vihuela* initially was used in a general sense to indicate instruments that could be bowed, plucked, or played with a plectrum, but it was the plucked form that rose to prominence and so the vihuela became identified as that alone.

It was strung with six pairs, or courses, of gut strings, much like the twelve-string guitar of today, and music of considerable sophistication was written for it by three principal composers: Luis de Narvaez, Alonso Mudarra, and Luis Milan. These Spanish musicians were probably the first in history to write music in an instrumental style that was not influenced by vocal music. Milan wrote the first book on vihuela music, *The Book of Music for Hand-Plucked Vihuela Entitled The Teacher.* This appeared in Valencia in 1535, and a golden age for the vihuela ensued, during which it was prominent in the Spanish court. The instrument was refined and aristocratic, with a body of music to match. Still, it was short-lived, and was replaced at the beginning of the seventeenth century by the four course guitar.

Easier to play than the vihuela, the four-course guitar quickly became popular in France and Italy. As a result, however, through the next century the quality of composition for it degraded as the instrument spread in popularity. As a result, the complex contrapuntal music of the plucked vihuela was replaced with simple instruction methods and *rasgueado,* or strumming, techniques.

A step toward the modern six-string guitar was taken later in the seventeenth century with the introduction of the Baroque guitar, which had five pairs of strings, again originating in Spain. The Baroque guitar enjoyed a degree of popularity, but during this same period keyboard instruments began to replace the guitar in general affection, although in Spain the guitar of course remained a fixture in everyday life.

The Baroque guitar underwent several design modifications until the use of strings in pairs was mostly abandoned and the modern guitar with its six single strings came into existence. Although there is no certain exact date, the six string is thought to have arrived around 1780, and it is likely that it happened simultaneously in both Italy and Germany. By about 1800, the stringing of guitars in five and six courses had effectively disappeared altogether in favor of the six single strings.

It might be said that the six-string instrument, with its now essential female form, was finally the perfect realization of the instrument, for its advent spawned new virtuosi of the instrument: Spaniards Fernando Sor, Dionso, Aguado, and Julián Arcas, and Italians Matteo Carcassi, Guilliani, Carulli, Regondi, and Paganini. These maestros developed new music for the guitar and worked with luthiers in Spain, England, and Vienna on further technical improvements to the instrument. Their teaching, writing, and playing across the European continent brought about the first golden age of the guitar.

Around 1850, an important new guitar maker started working in Madrid. Antonio Torres designed a new pattern of fan strutting to reinforce the soundboard, a wider neck, and a wider body. He was encouraged in his efforts by the great Spanish guitarist Francisco Tarrega. Tarrega made a significant contribution to the development of the modern classical guitar by not only composing many original pieces, but also by transcribing the works of many classical composers for the guitar, including Bach, Beethoven, and Schubert. In 1895 another great guitarist, Andres Segovia, was born in Linares, Spain, and it was he who carried the Tarrega torch into the twentieth century, bringing the guitar to the attention of the modern world and giving it a place of importance as a classical instrument. He accomplished this by giving concerts around the world and by being a tireless ambassador for the guitar. He also encouraged many composers to write for the instru-

ment and made endless transcriptions in an effort to expand the available literature.

One aspect of the life of the classical guitar that has bothered many guitarists and other musicians has been the relative lack of substantial contemporary music especially written or transcribed for the instrument. While guitarists like Sor and Guilliani were virtuosos on the instrument, most of their own compositions tended to be light in character—as is true to a large extent of most of the music written for the instrument throughout its various periods, with the possible exception of the music of the great Vihuelistas. In spite of their achievements in heightening the reputation of the classical guitar, neither Tarrega nor Segovia did much to address this imbalance. Both were of a nineteenth-century sensibility and seemed even to have an aversion to the more interesting music of their time, ignoring composers like Stravinsky, Bartók, Hindemith, and Schoenberg. So they may have in a sense held back the view of the classical guitar as a serious instrument of ongoing relevance. A slight balance was only achieved with the transcriptions of weightier composers like Isaac Albeniz.

With the arrival of the great Julian Bream in the late 1950s, the balance began to change. Bream launched a personal campaign to raise the level of the guitar literature and succeeded in doing so by commissioning many of the most important composers of the second half of the twentieth century to write for the guitar. Bream as an individual had a remarkable amount to do with the guitar's rise to general pre-eminence in the world from that time forward. The last forty years could be seen as the second golden age of the guitar, for during those decades and continuing, the guitar has gained a strong following around the world that could not have been imagined in earlier periods.

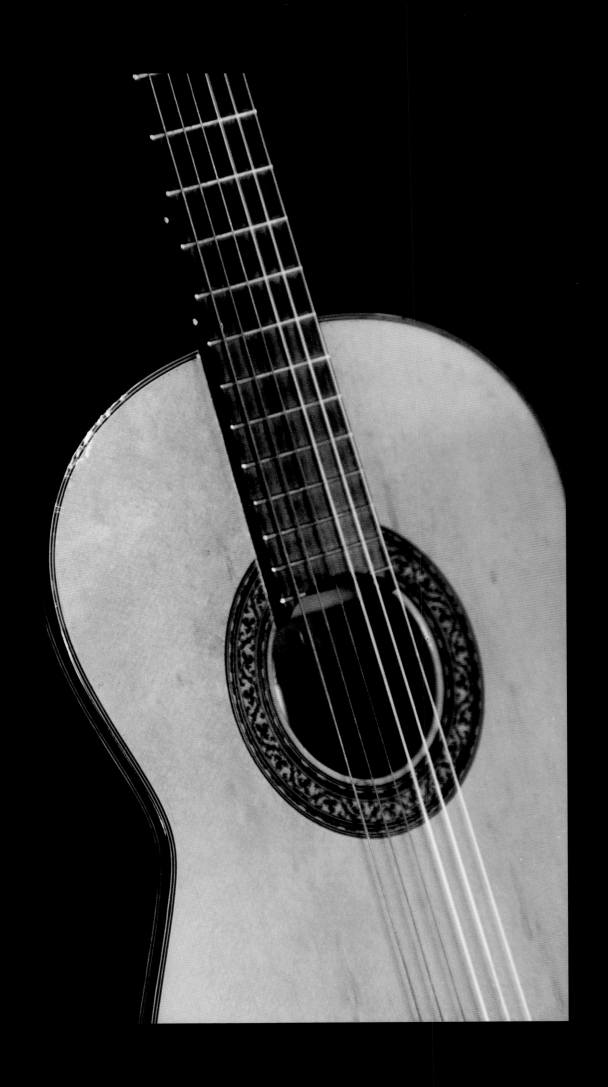

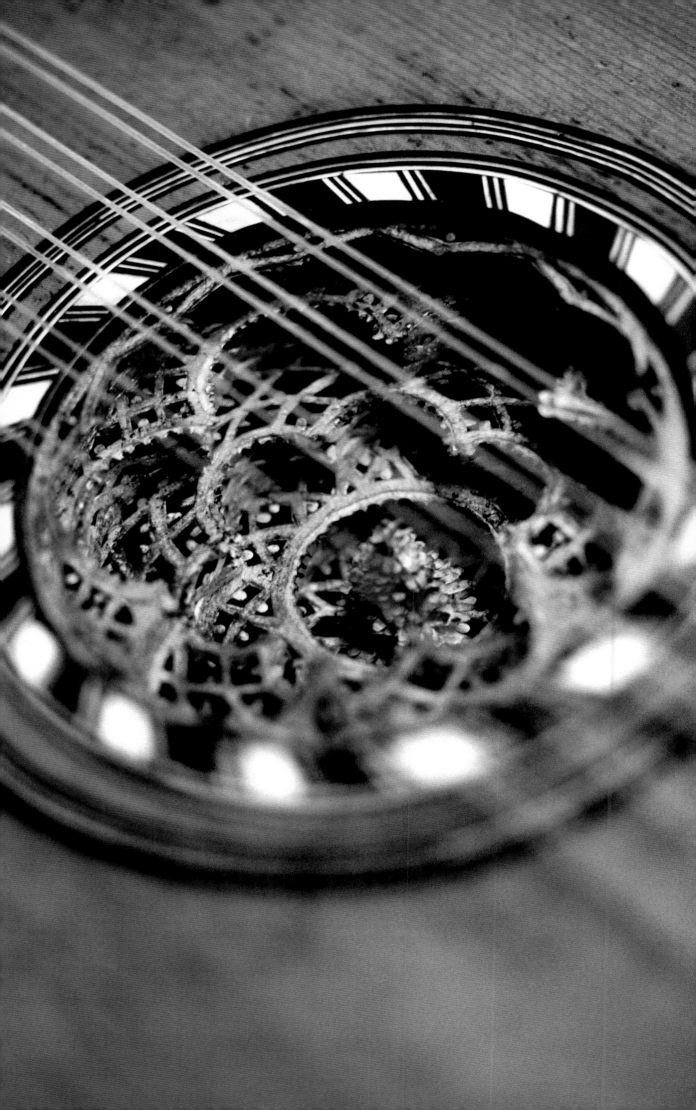

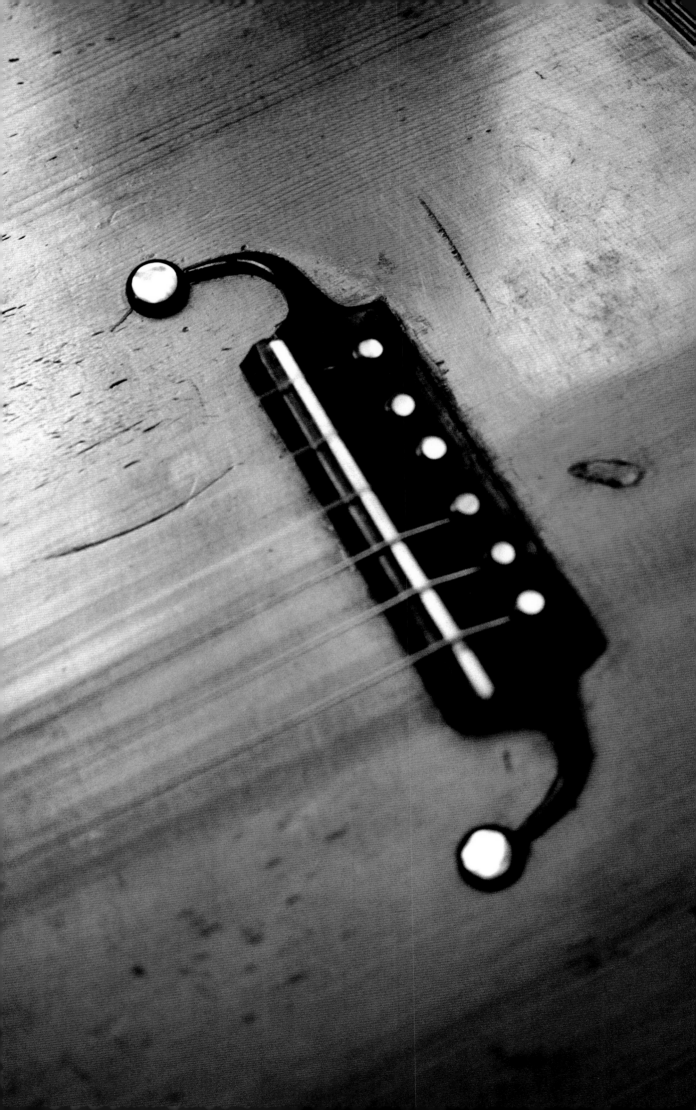

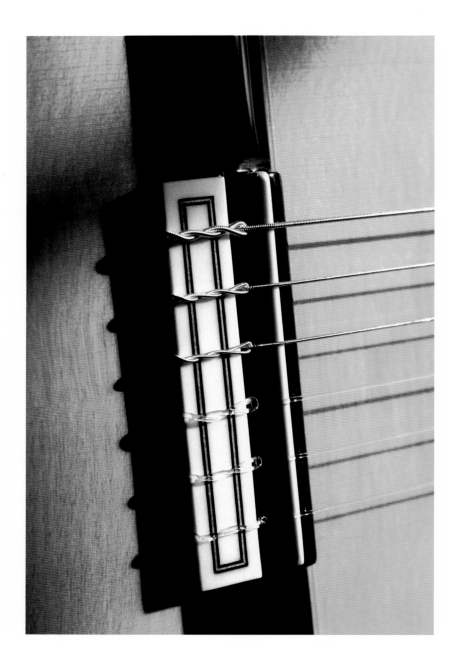

The bridge serves a number of crucial functions: it determines the correct spacing of the strings, their height above the fingerboard, and is the anchoring point for the strings on the soundboard. . . .

For the first four hundred years the bridge simply consisted of a rectangular block of hardwood like ebony or rosewood or occasionally walnut. This was extended by a small flat platform behind the block, which extended the bridge's gluing surface. The strings ran through the block of these bridges and were then tied in place to the bridge itself. As the six-string guitar became a reality, French and Italian guitar makers dropped the idea of the tie-block design and invented the pin bridge, wherein the string is dropped into a hole in the block and then held in place by a pin rather than being tied around the block. The Spanish guitar makers kept on with what some considered the archaic block design, but added a wing on either side, which not only gave it stability but added a decorative function. Torres came up with a synthesis of several ideas that were in the air at that time and created the modern classical guitar bridge with its side wings and removable bone saddle and moved the tie block to the rear. In New York C.F. Martin took the pin-bridge design and created the modern steel-string bridge. The electric guitar in all of its various guises has been the recipient of many bridge designs; because of its greater reinforced body strength there has been more latitude and experiment in what a bridge can do. One of the most interesting variants was Leo Fender's Tremolo Arm which connected to a bridge that literally floated inside the body and was capable of raising or lowering the string pitch, an idea that would maybe have been inconceivable to luthiers a couple of centuries earlier. Gibson came up with the Tun-o-matic bridge, whereby string length could be adjusted by movable saddles, thus ensuring even more accurate tuning.

Les Paul invented the Trapeze/bridge tailpiece, which was a structure that combined the two.

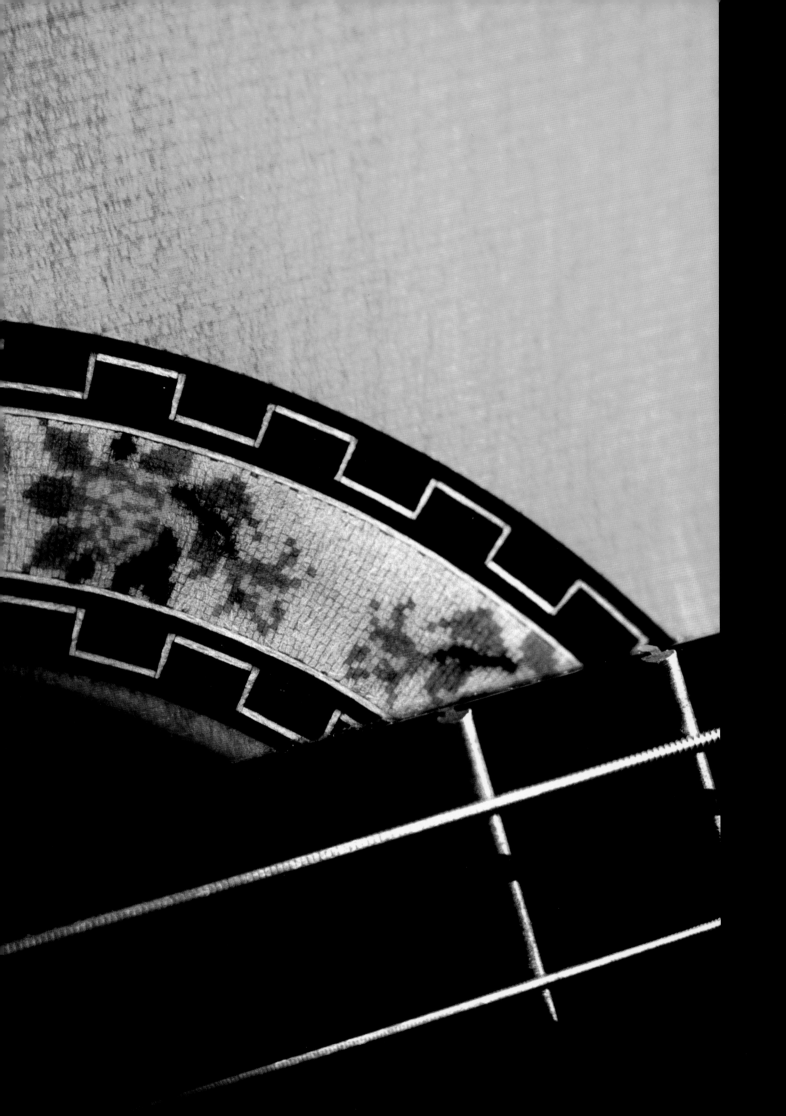

The soundboard resonates and vibrates with the movement of air in the sound chamber below. Braced and taut, it is like the skin of a drum over the belly of the guitar. It may be carved like a violin or cello as in the archtop guitar, or flat, as in the flamenco instrument (although certain guitarreros are known to put in a subtle arch). Made from the softwoods of spruce or cedar, it is the harmonic top of the guitar and the plane through which the music reaches the world. Many consider it to be the component that will make a guitar great.

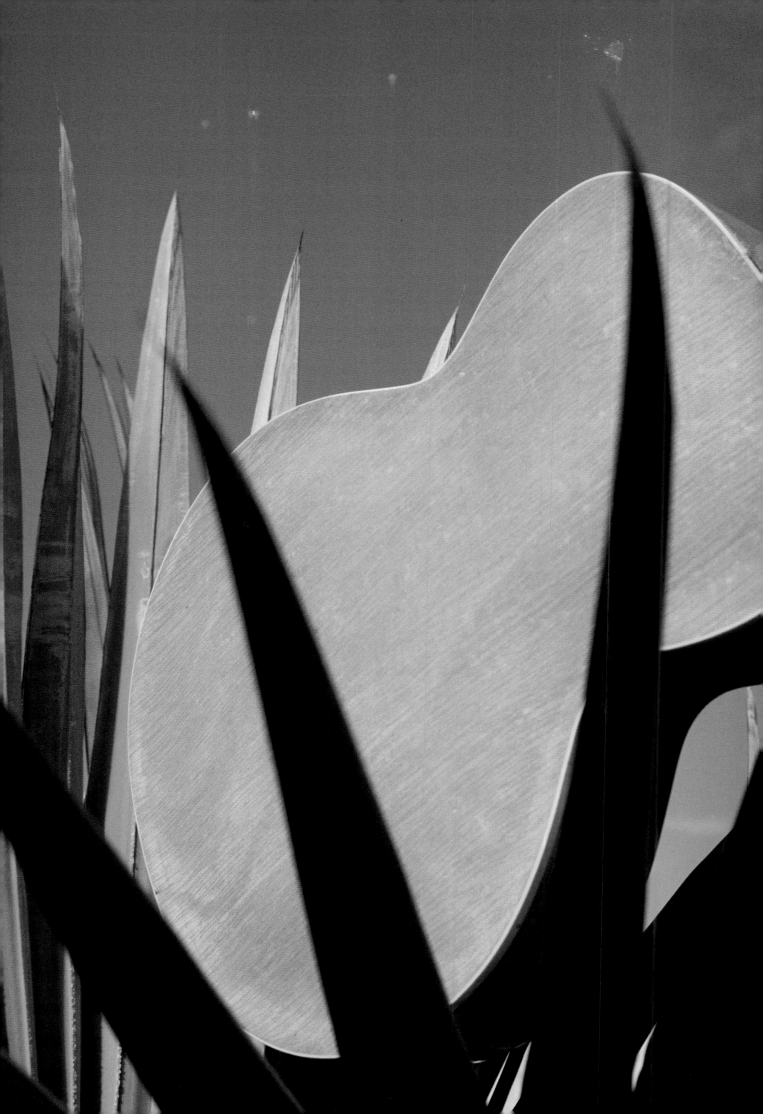

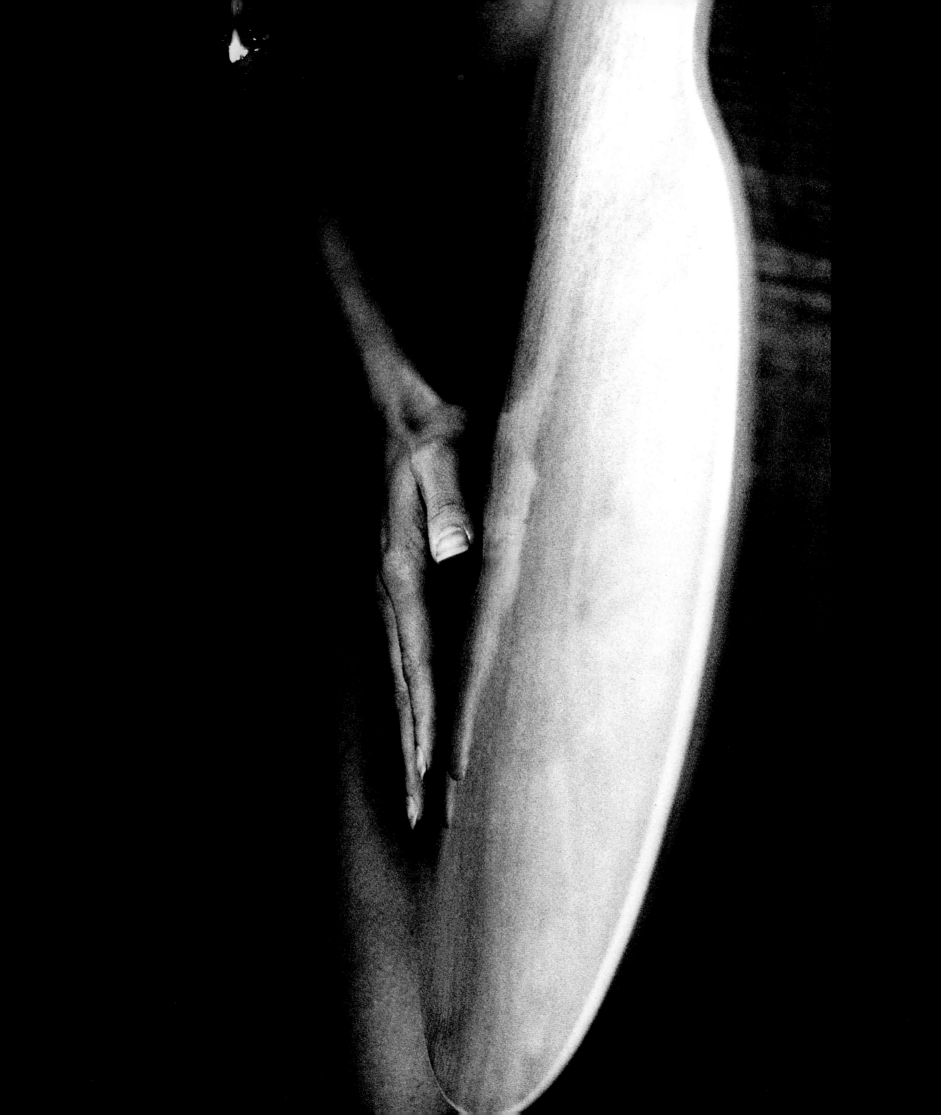

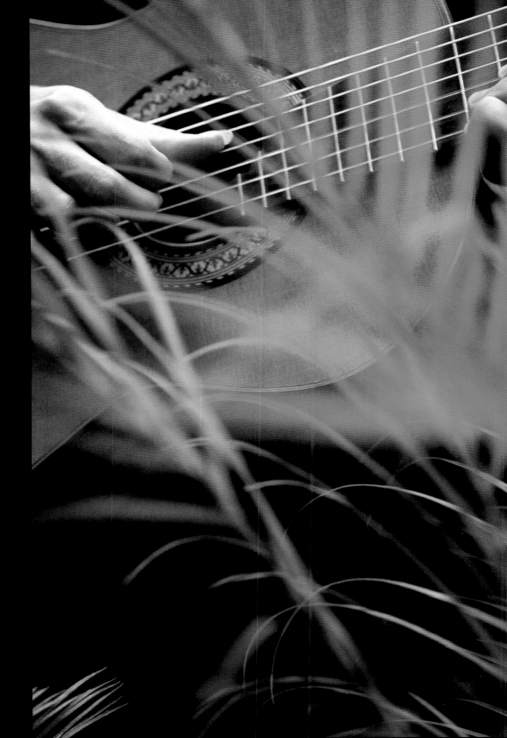

1958 a new style of music emerged from Brazil that was to take the world by storm during the 1960s: it was called bossa nova. The principal inventor of this new form was João Gilberto, who devised a new rhythm on the guitar as a song accompaniment—basically a slightly simplified samba—which was known as soft or cool samba. Along with Gilberto were two other young Brazilian musicians, Vinícius de Moraes and Antonio Carlos Jobim. This trio was responsible for the birth of the movement and the composition of many world-famous songs like "The Girl from Ipanema," "The One Note Samba," "Desafinado," etc.

The bossa nova guitar style might be described as soft and sexy, subversive rather than strident. One of the characteristics of this style is its borrowing of jazz harmony, which differentiates it from the more simple harmonies of the samba. Within the bossa style many great guitarists and composers emerged such as Garoto, Luiz Bonfá, Roberto Menescal, Baden Powell, Laurindo Almeida, and Edu Lobo.

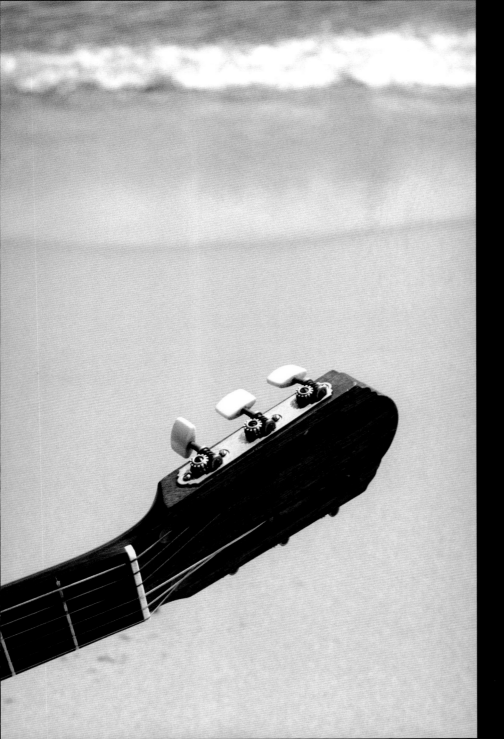

The bossa nova style is usually played on a nylon-string guitar with the right hand in the classical style rather than with a pick. The chords are plucked in an accented rhythm against a bass line that is picked out with the thumb on the fifth and sixth strings. Harmonic substitution is used replacing more conventional pop harmony.

All of these elements add up to a heady brew that is soft, sophisticated, and seductive, but ironically the sophistication of bossa nova led to its own demise as a widely popular music, for in some ways it is too intellectual and progressive for a mainstream audience, even in Brazil.

The MPB movement or "Musica Populaire Brasileira" lasted through the sixties and into the early seventies when it began to be overtaken by rock and tropicalismo.

The music of musicians for musicians, bossa nova may be seen in retrospect as a brilliant flowering of the fusion that is the music of Brazil.

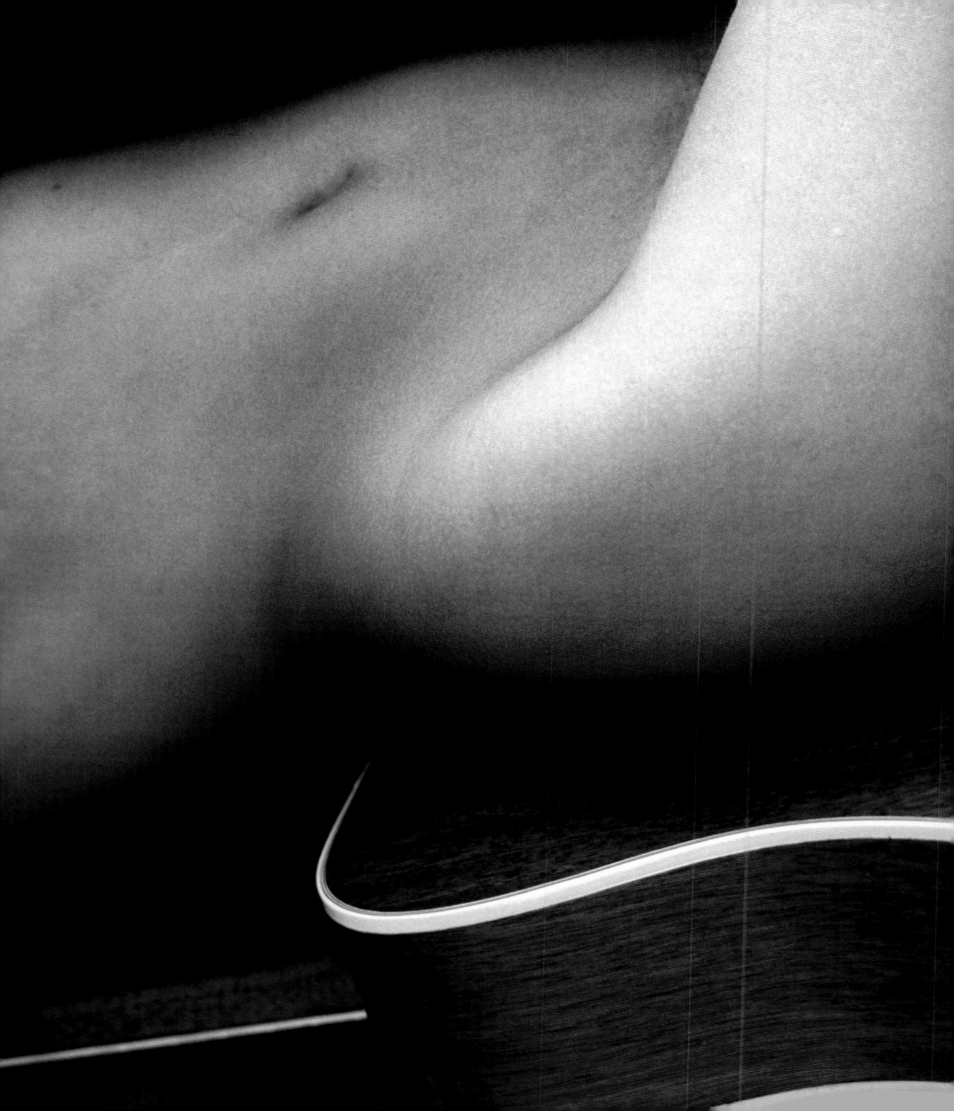

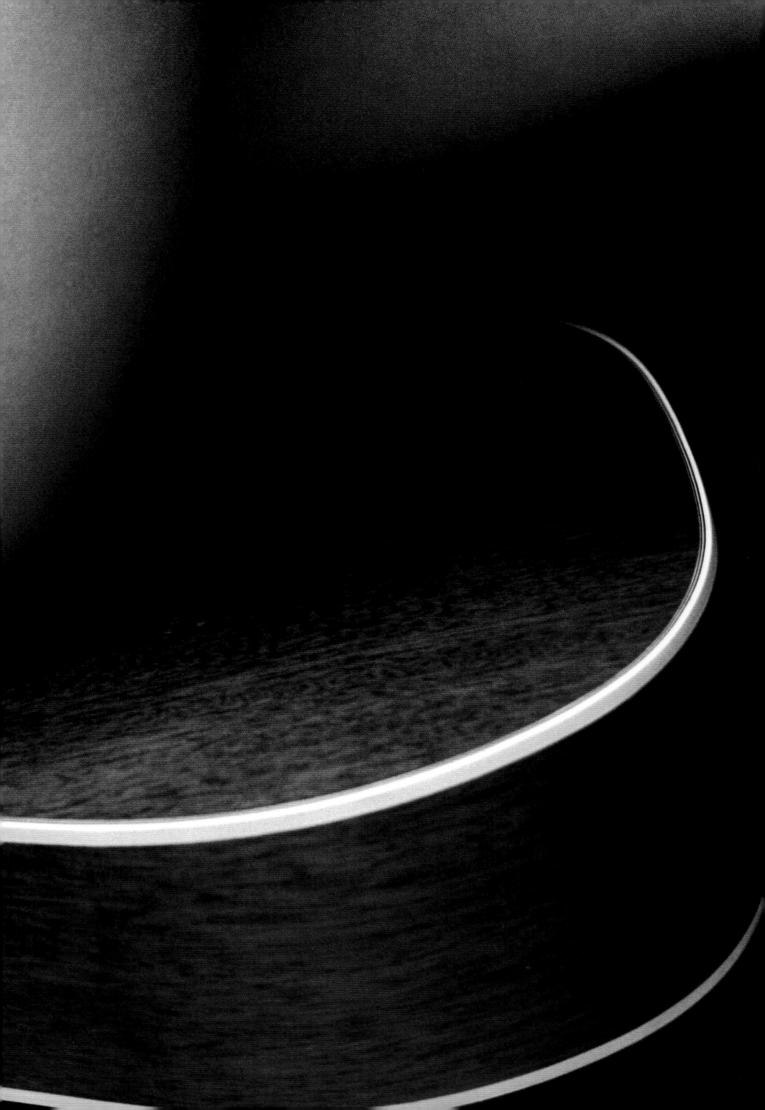

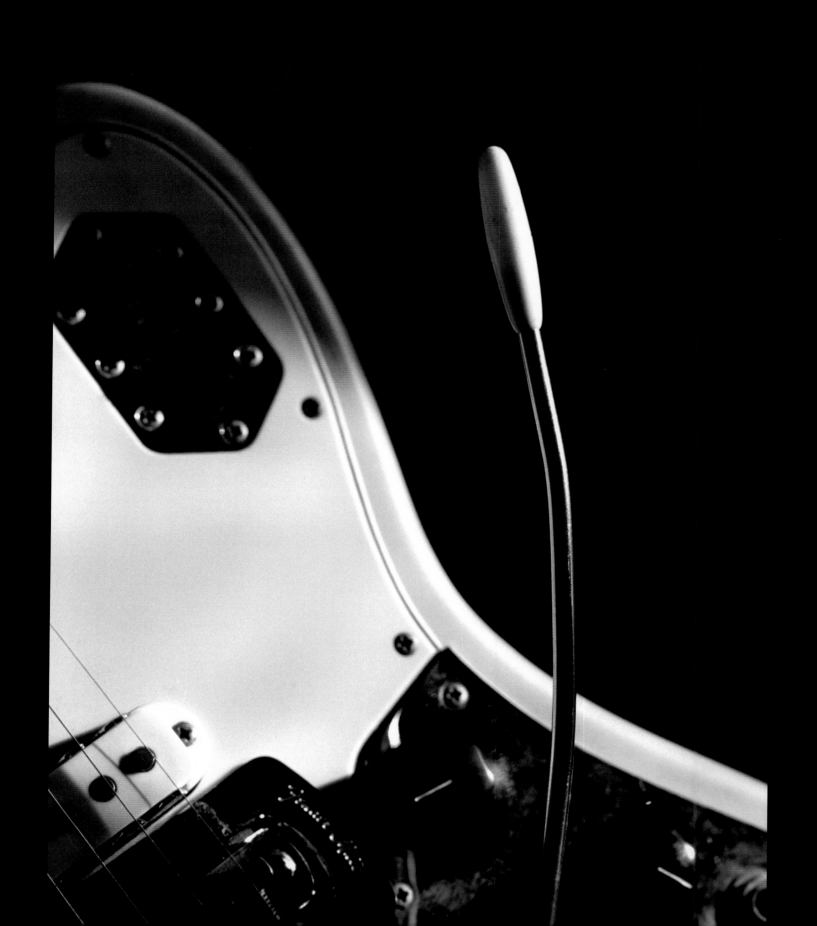

. . **you stand on stage** in front of the mob with
a Strat or a Les Paul around your neck the amp
behind you cranked up way high to uncage the
power that is animal sexual the force that
stabs and roars at the lower chakras like a lion
in heat Bacchus awakens and the night unfolds
its wings like a bat feedback distortion the
blood-curdling banshee wail of the cranked
guitar the thick creamy sound of the overdriven
humbucker or the single-coil back pickup of a
Strat cutting like a knife and driving the audi-
ence into dementia you step forward hit the
fuzzbox and rip out a solo youth sexuality and
power radiate like the sun in a churning arc
from the pickups to the audience c'mon baby
light my fire the guitar lead snakes across the
stage as you bend into the energy of the audi-
ence bent-string lunar feedback and the weight
of the crowd force crash burn and surge into
orgasm right here right now—naked. . . .

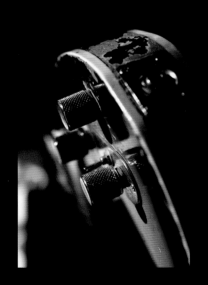

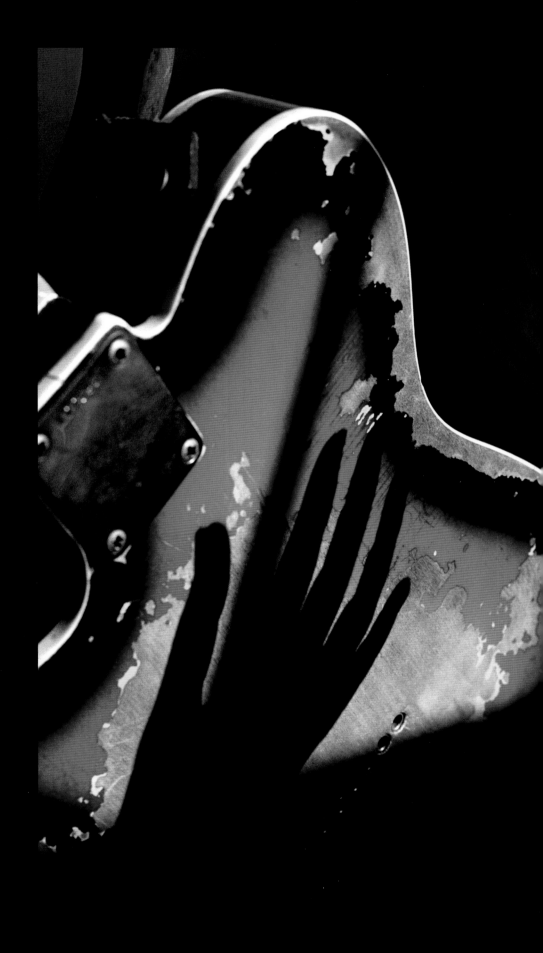

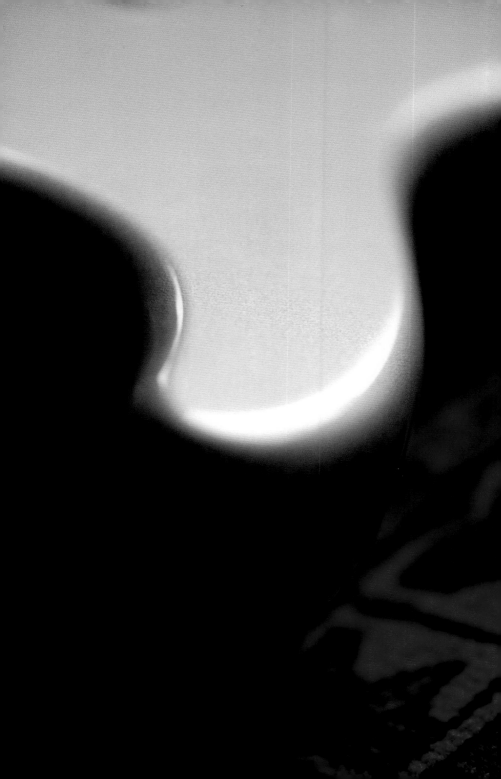

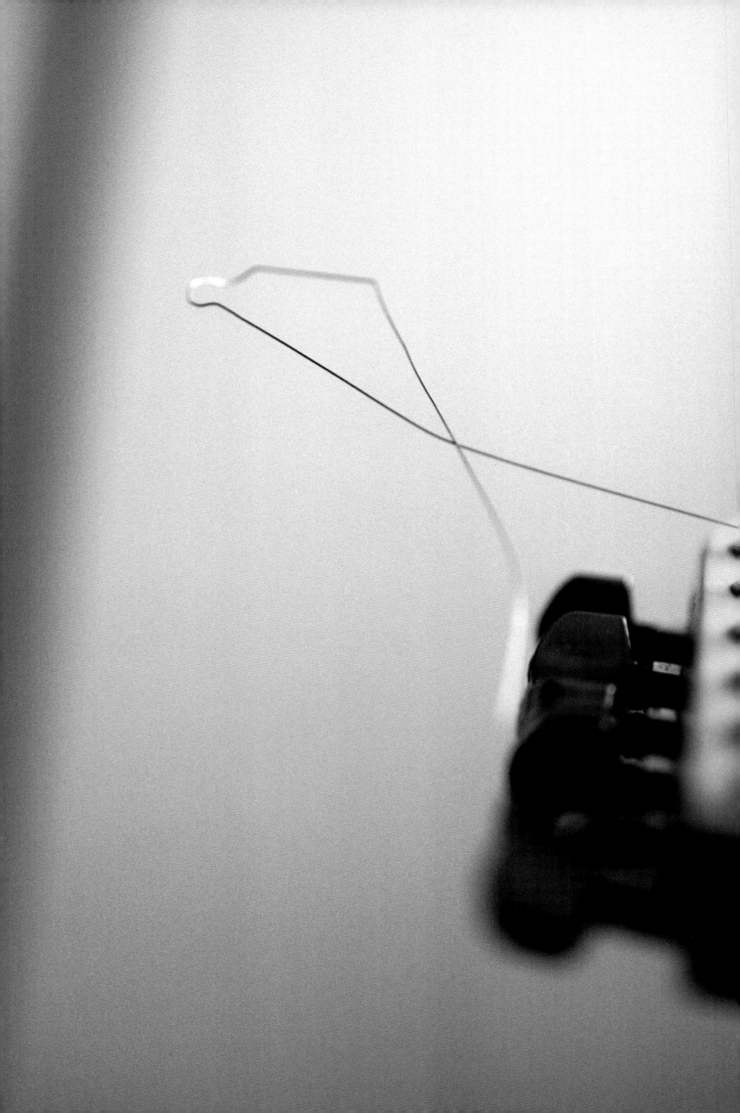

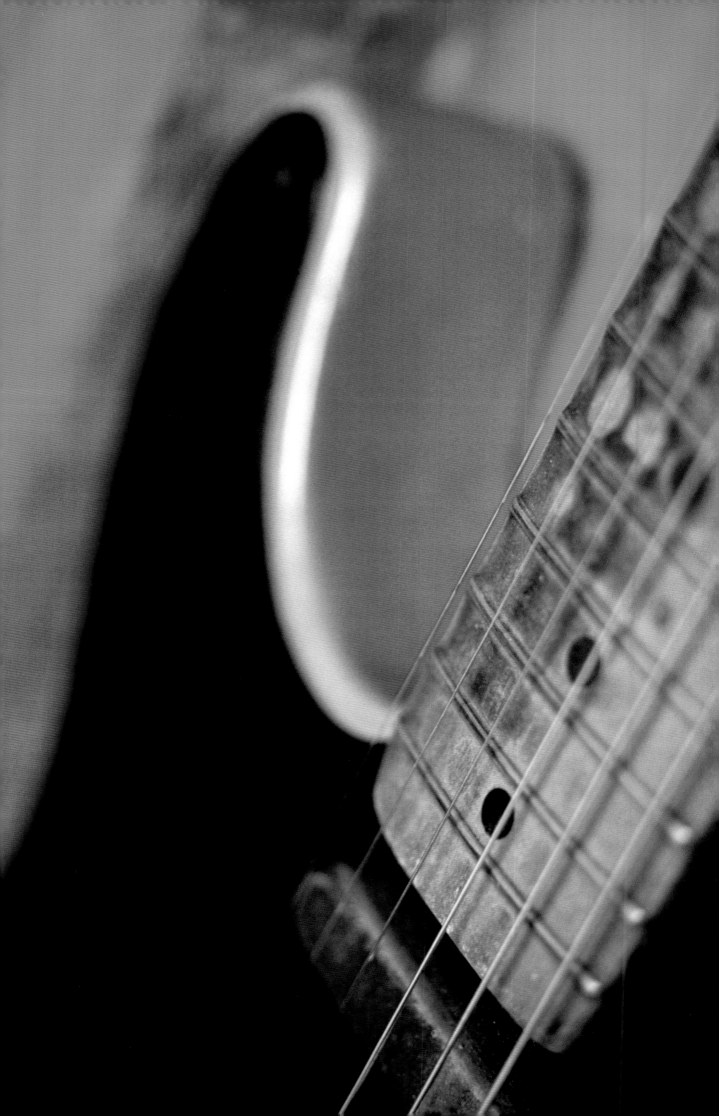

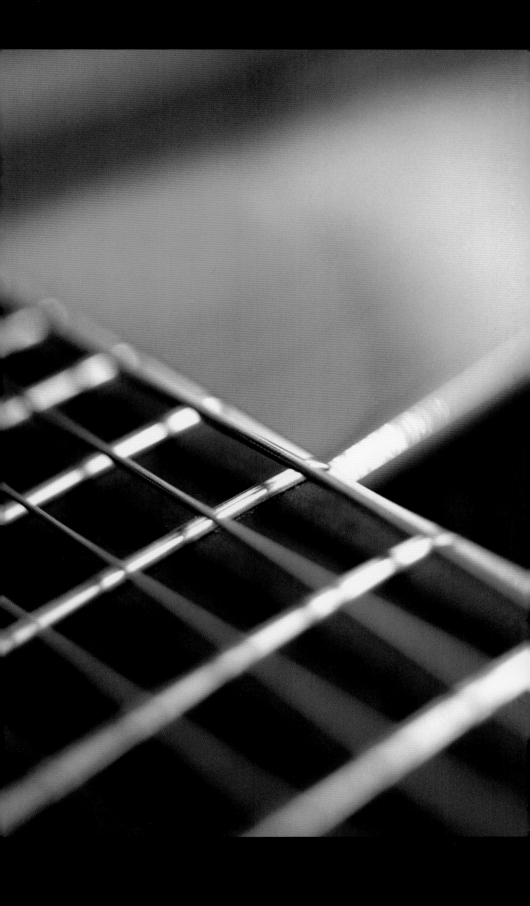

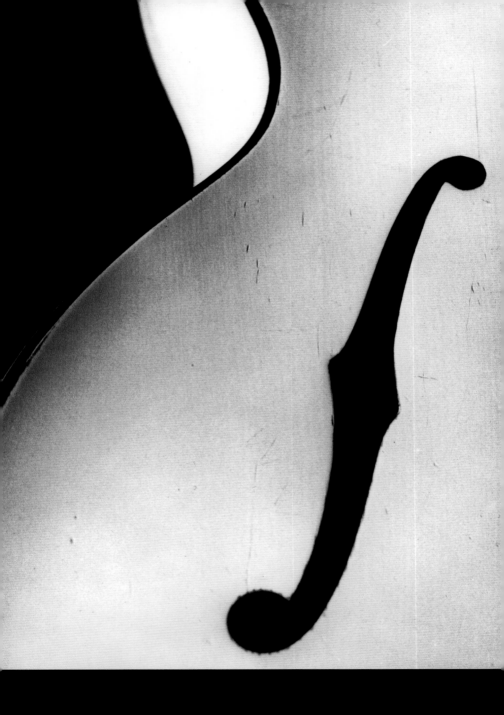

The steadfast "O" shape of the original sound hole finally drifted lat-
erally across the guitar in 1885, when Orville Gibson—whose methods
were ingrained in the method of Italian violin and mandolin construction,
and who was already carving his soundboards with the curves and
slopes of the violin—was inspired to take the transformation one step
further. Thus the O became an F, and has forever since been an integral

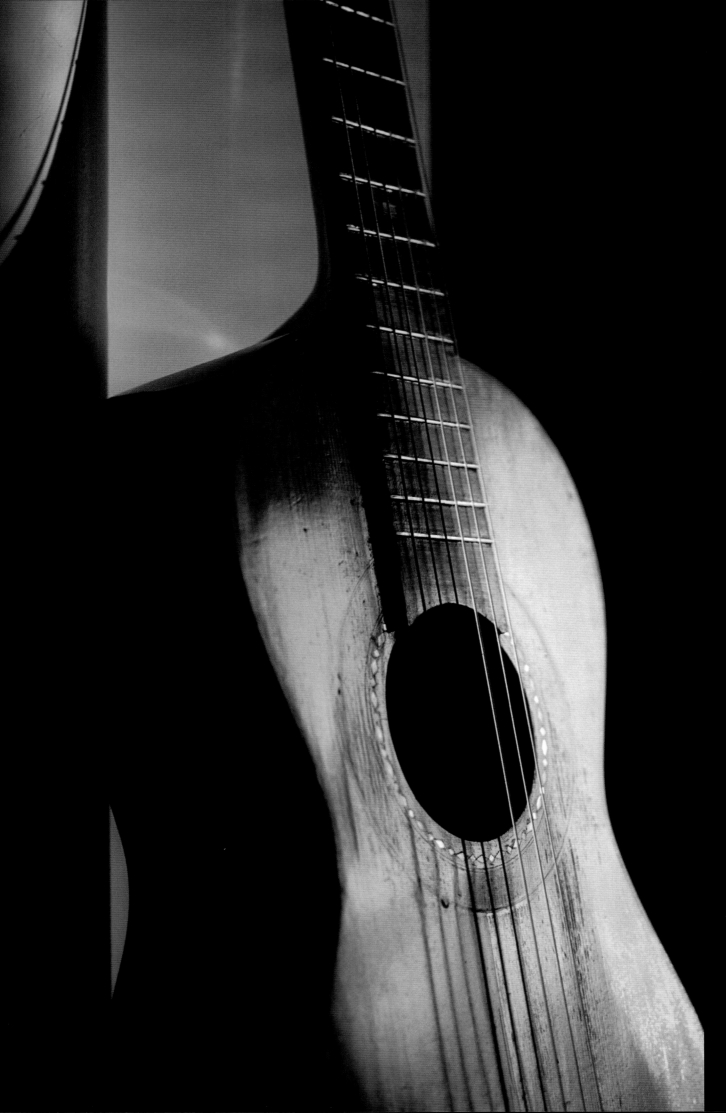

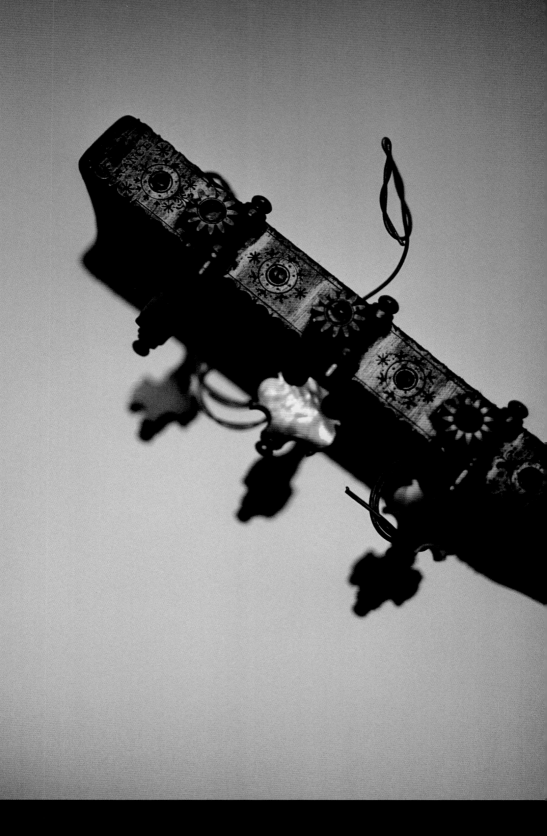

The string vibrates, and the wave travels down and around the dark acoustic belly of the guitar where it gains tone, volume, and character. These qualities are formed and colored by the cedar or spruce used for the soundboard, the X or fan of bracing inside the chamber, the depth of the body, and also the ability and will of the luthier. The notes ascend upward and outward through the mouth of the

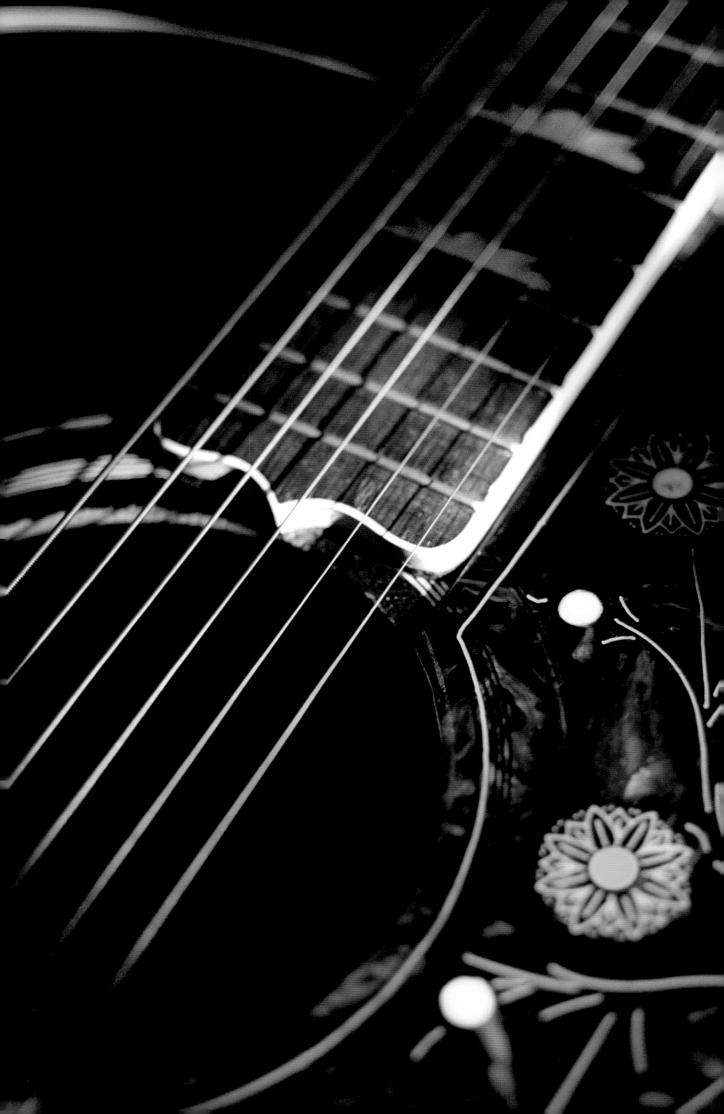

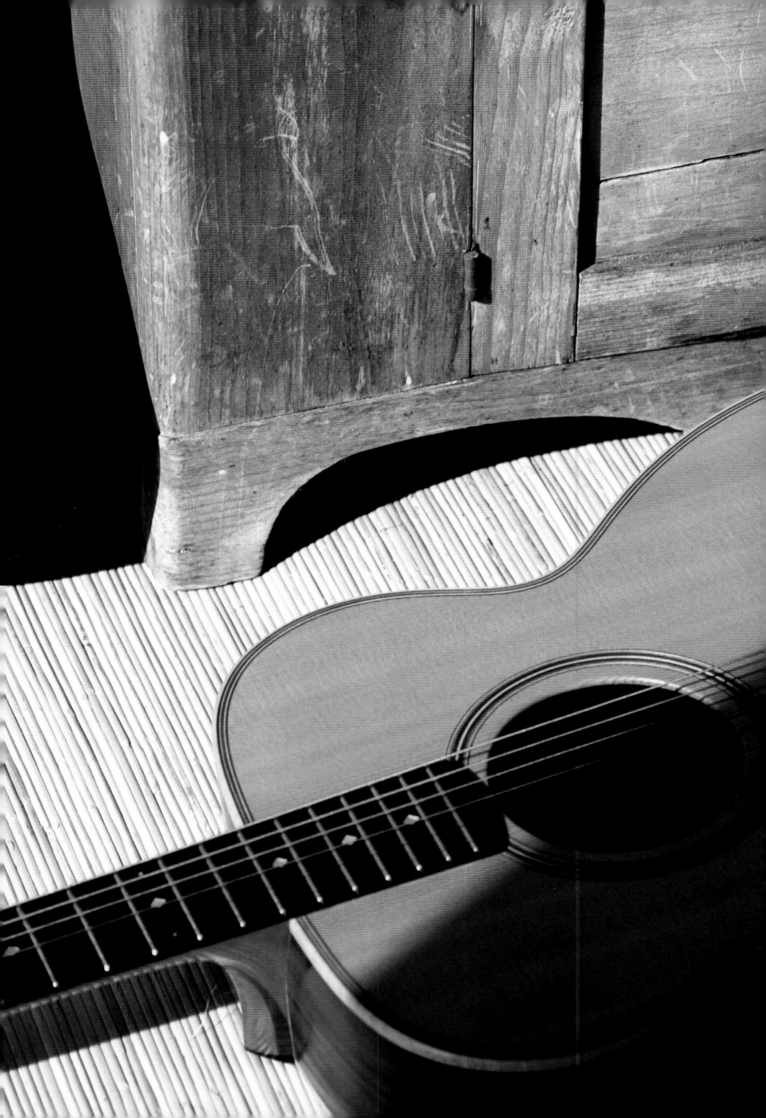

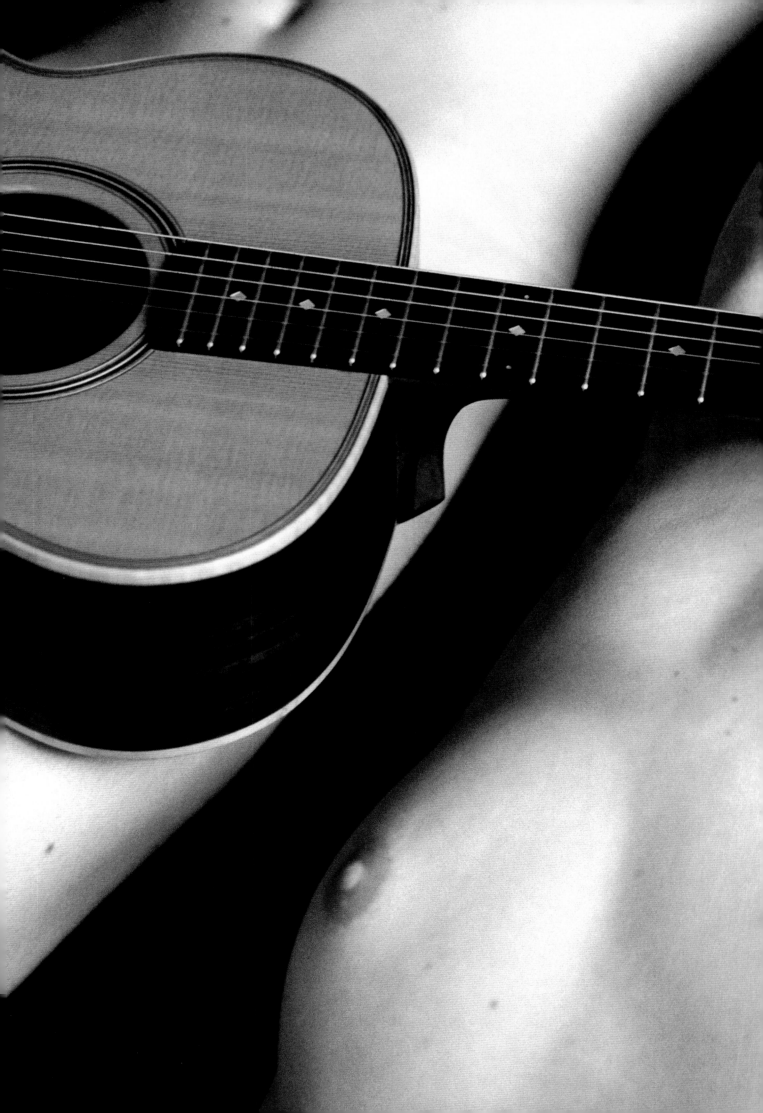

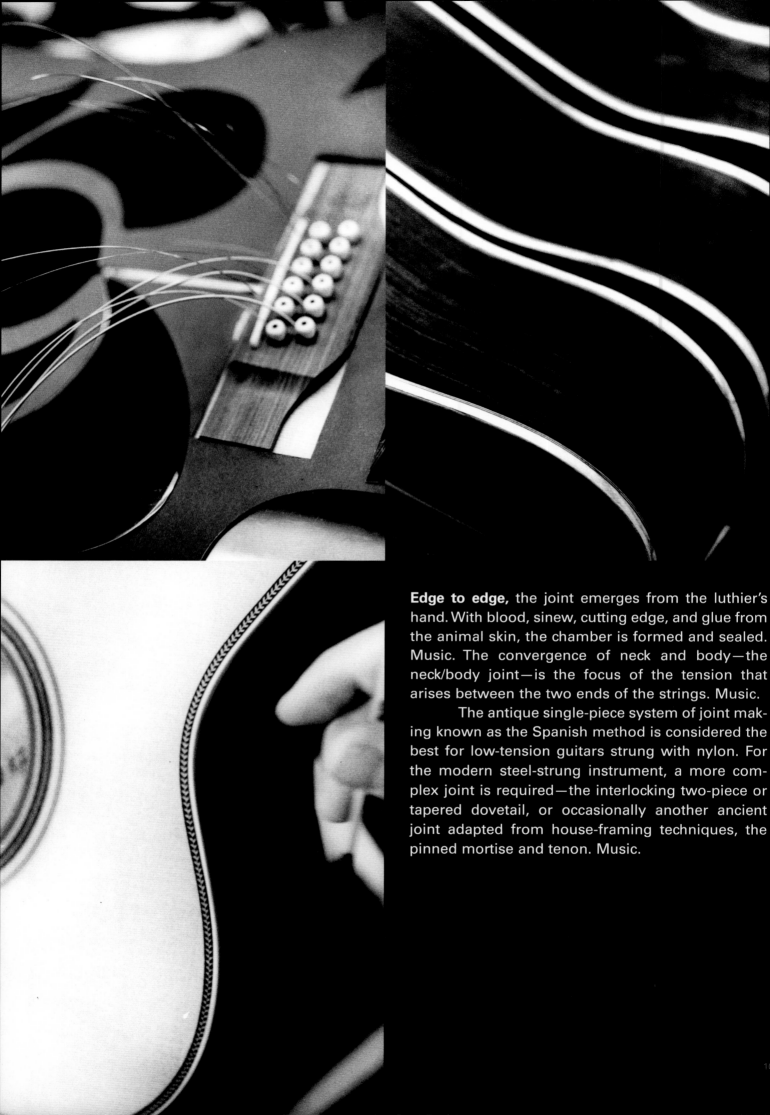

Edge to edge, the joint emerges from the luthier's hand. With blood, sinew, cutting edge, and glue from the animal skin, the chamber is formed and sealed. Music. The convergence of neck and body—the neck/body joint—is the focus of the tension that arises between the two ends of the strings. Music.

The antique single-piece system of joint making known as the Spanish method is considered the best for low-tension guitars strung with nylon. For the modern steel-strung instrument, a more complex joint is required—the interlocking two-piece or tapered dovetail, or occasionally another ancient joint adapted from house-framing techniques, the pinned mortise and tenon. Music.

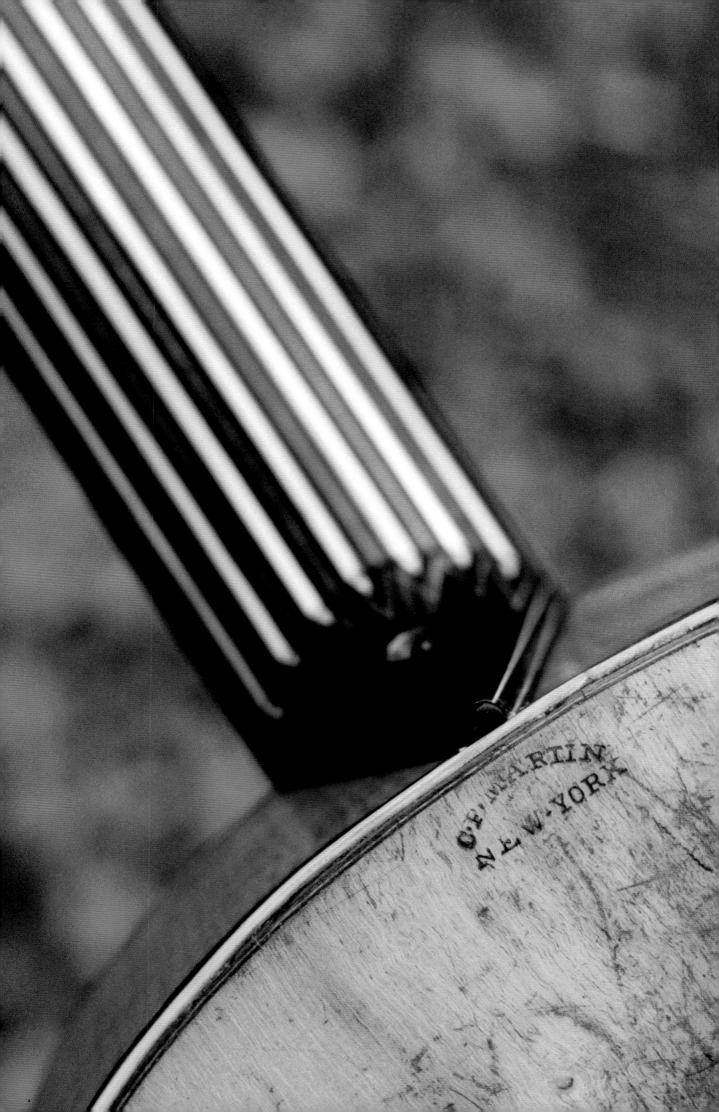

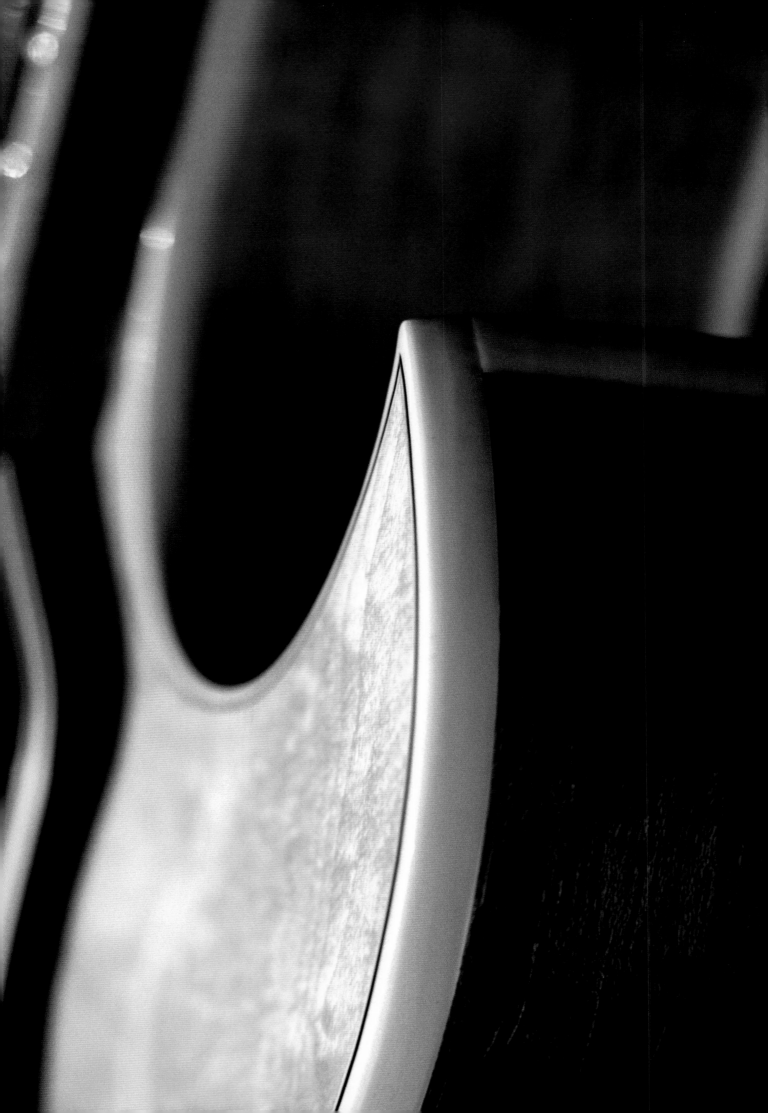

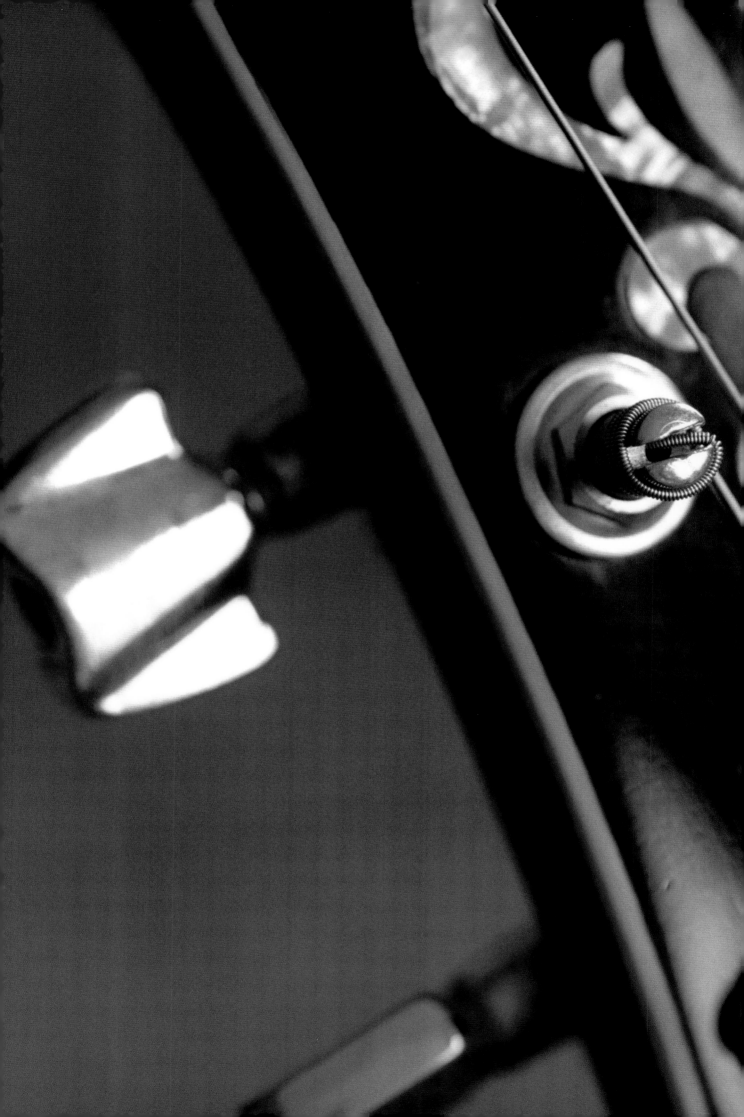

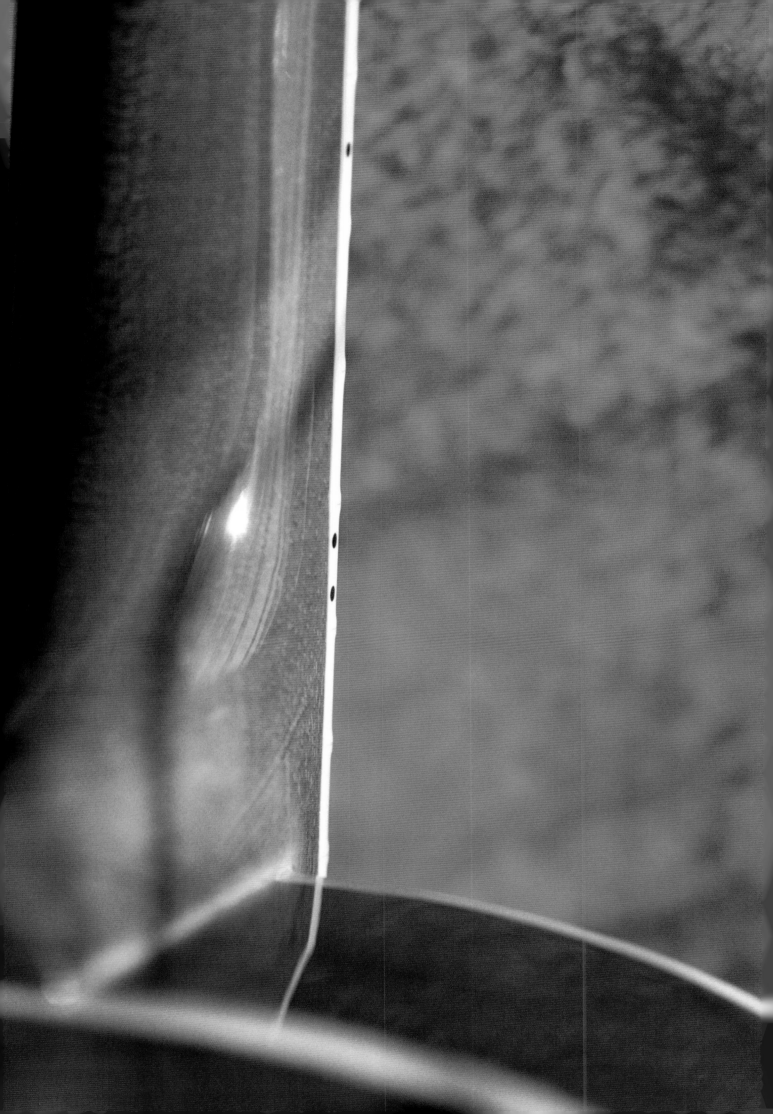

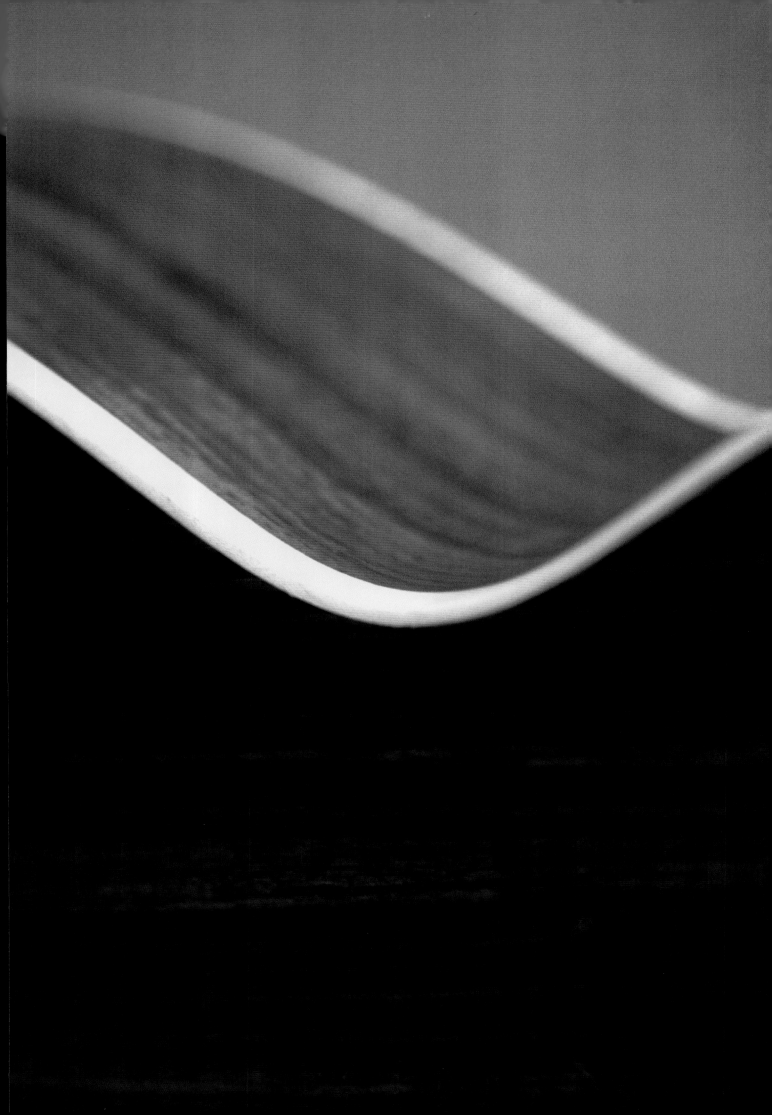

I started playing the ukulele when I was twelve and soon outgrew it. At thirteen I received a flat-top Gibson, probably a J200, and lessons from Duke Miller, a prominent teacher in North Hollywood during the 1950s. Duke taught me how to read music and play Malaguena. I read somewhere that Charlie Christian dismantled the arm on a phonograph, placing the pickup under the strings. I did the same thing and turned up the volume. My fifteenth birthday was graced by a new ES-175 and lessons with Red Varner, who showed me some jazz moves on his new Les Paul Gold top. This instrument made an extraordinary impression on me, both fascinating and confusing. I had never seen such an object.

At seventeen I went into the Navy and was sent to photography school in Pensacola, Florida. Upon graduation I was sent to sea as a photographer's mate and kept a guitar in the darkroom. I would study scales and play classical pieces for the next few years. In 1960 I was discharged and headed straight into art school where I studied photography and starved. About this time I was offered a job playing guitar in the cocktail lounge of a luxury liner ready to embark on a long cruise. I realized that a serious decision had to be made, a choice between photography and music. Photography had to win but that didn't mean divorcing the guitar . . . just my illusions. For the next 40 years I continued to play and follow the evolution of the guitar. The amplifier in my studio is never turned off. I play throughout the day and still wonder how far the instrument will take me.

Doing this book with Andy is an opportunity to express feelings for the guitar in visual terms that I could not express in musical terms. I was going to call this book *Blues in F/8*.

Ralph Gibson

New York City 1-16-04

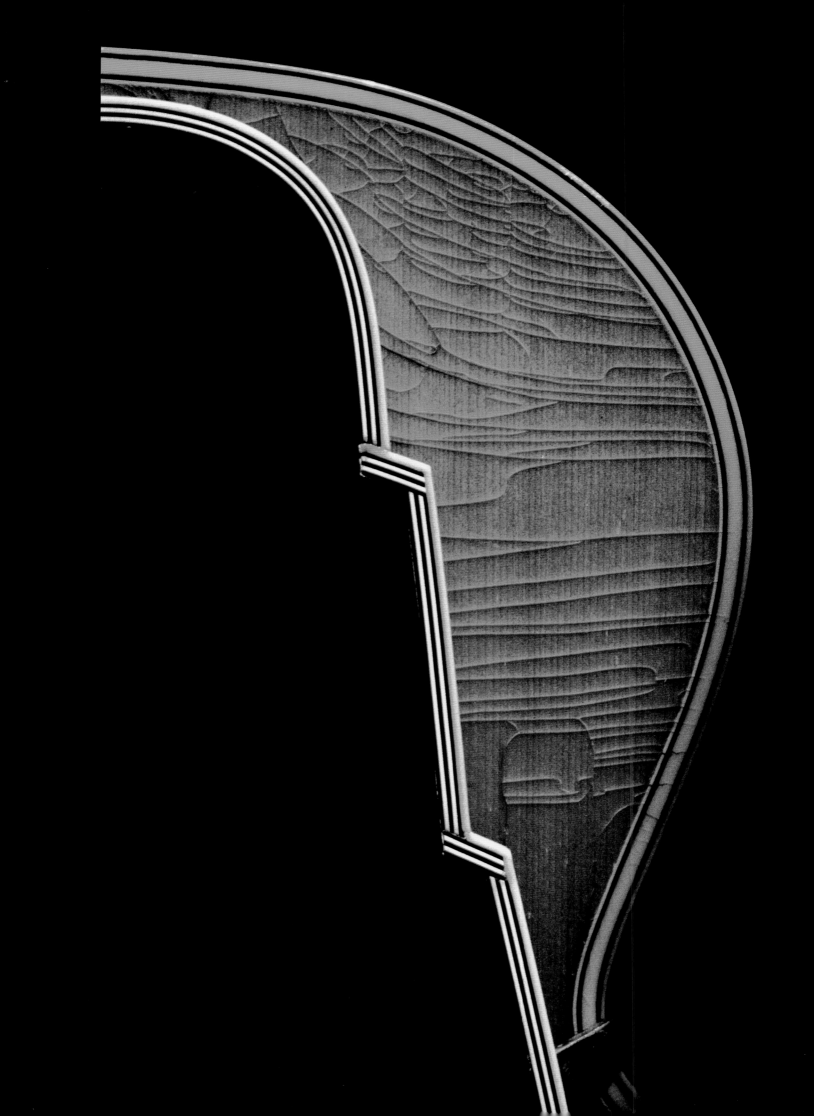

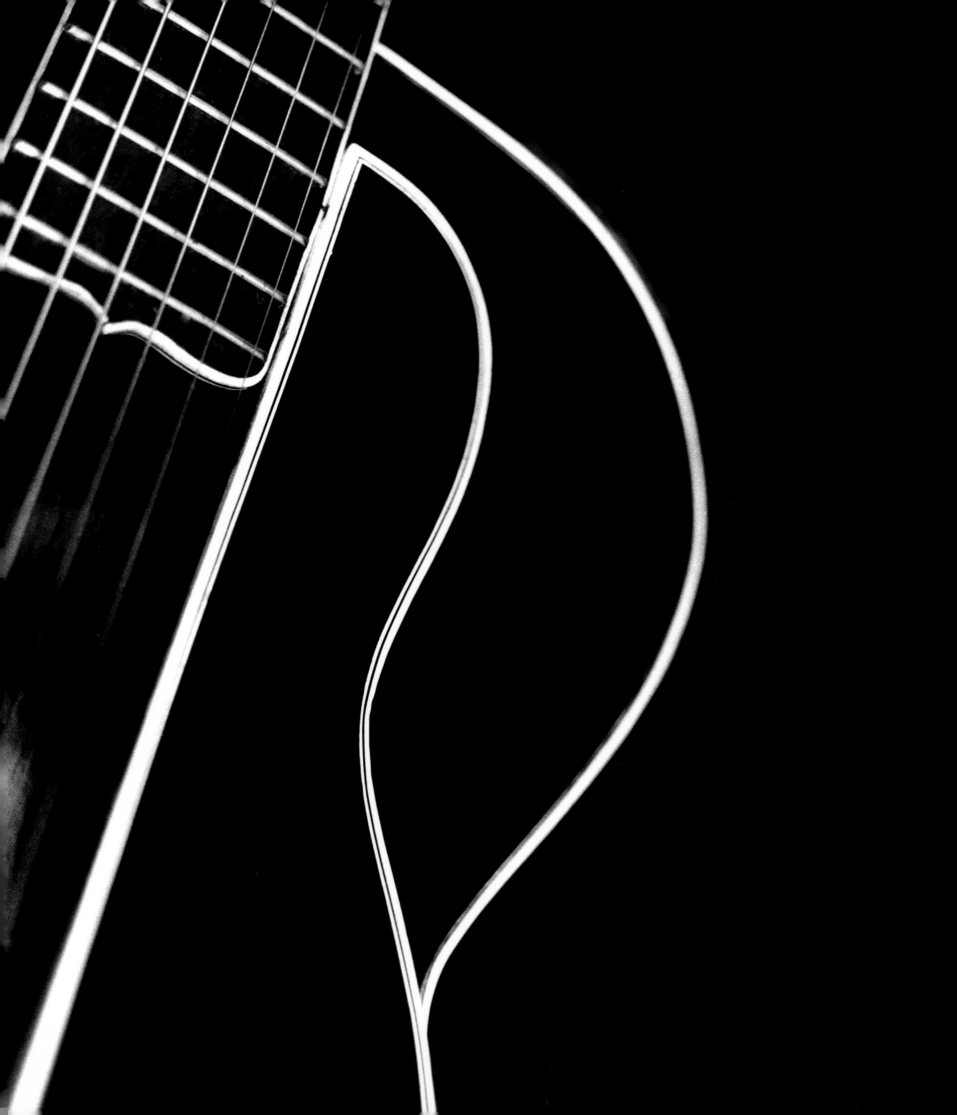

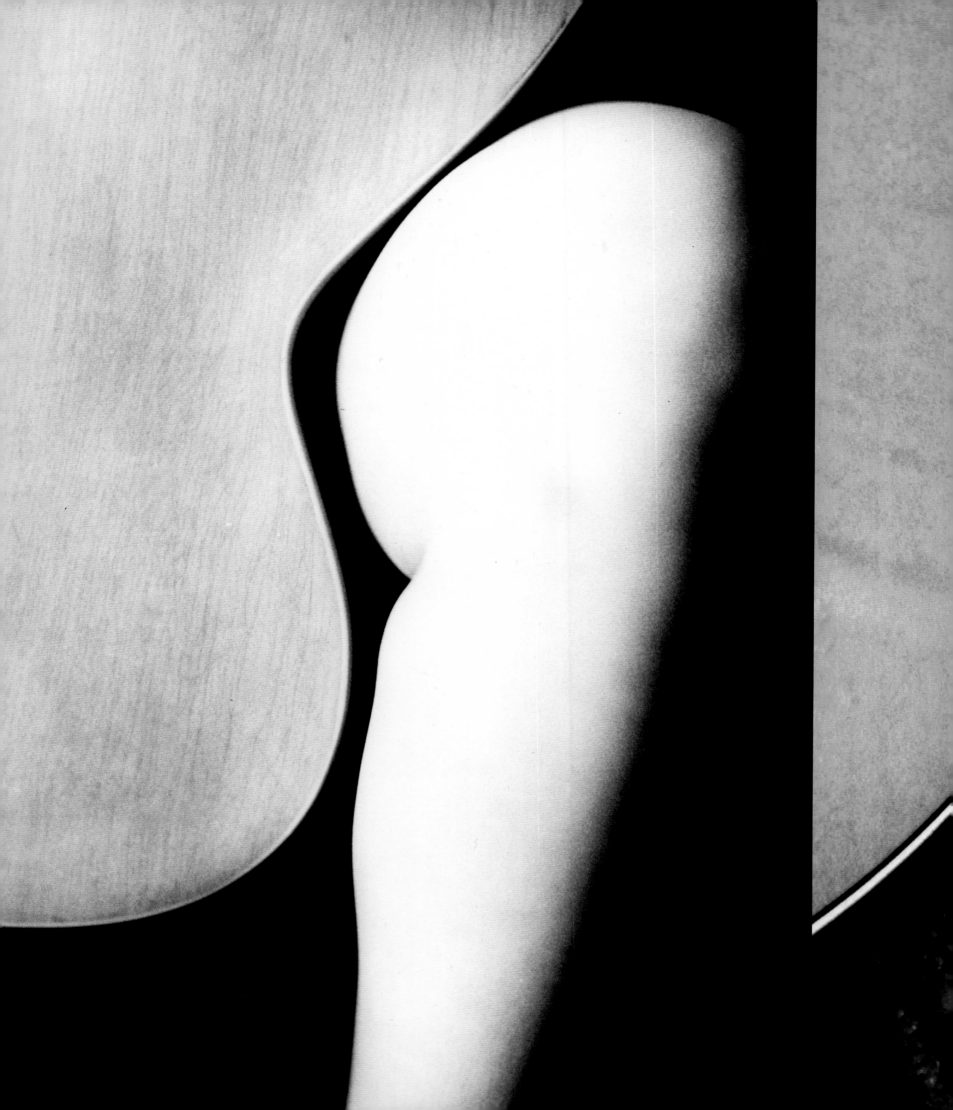

LENDERS, LOCATIONS, COLLECTIONS

Front Cover: Lloyd Loar L-5, Courtesy of Lark Street Music, Teaneck, NJ

2	Craig Pedersen Guitar, Collection of Ruby's Music, New York, NY
3	Anon
6	Charlie Christian, Courtesy of Frank Driggs Collection
7	Django Reinhardt, Courtesy of William Gottlieb
8–11	Gibson Custom Shop, Nashville, TN
12	American Archtop Guitars, Stroudsburg, PA
14–23	Gibson Custom Shop, Nashville, TN
24	Top Left: American Archtop; Top right: Gretsch Coll., Andy Summers; Bottom: D'Angelico
25	Right: D'Aquisto, Courtesy of Lark Street Music, Teaneck, NJ
26–27.	D'Angelico, Courtesy of Mandolin Brothers, Staten Island, NY
28	Studio of Tercio Ribeiro de Sousa, Rio di Janiero, Brazil
29	Steinberger GL-4, Collection of Ralph Gibson, New York, NY
30–31	Courtesy of Mandolin Bros., Staten Island, NY
32	Top Left: Lark Street Music, Teaneck, NJ; Top Right: Benedetto; Bottom Left: Recording King, Collection of Andy Summers
33	Gary Flowers, Baltimore, MD
34–35	Ibanez AS-200, Collection of Ralph Gibson
37	Nancy La Scala with Ward's Airline Guitar, Collection of Andy Summers
38	Ibanez AS-200, Collection of Ralph Gibson
40–41	National Style O, Dobro Guitar, Collection of Andy Summers
42–43	National, Dobro Guitars, Courtesy of Mandolin Brothers, Staten Island, NY
44–45	Gibson L-4, Collection of Ralph Gibson
47	Benedetto Cremona, Collection of Andy Summers
49	Orphée Lutherie, Paris
50	American Archtop Guitars, Stroudsburg, PA
51	Collection R.F. Charle, Paris
52	Benedetto Cremona, Collection of Andy Summers
53	D'Angelico New Yorker, Courtesy of Rudy's Guitars, New York, NY
54	Courtesy of Orphée Lutherie, Paris
55	Gibson L-4, Collection of Ralph Gibson
56	Benedetto Cremona, Collection of Andy Summers
57	D'Angelico New Yorker, Courtesy of Ruby's Guitars, New York, NY
58–59	Maccaferri Demonstration Photograph, Courtesy of R.F. Charle, Paris
60	Top Left: Courtesy of Orphée Lutherie, Paris; Top Right: Lark Street Music, Teaneck, NJ; Bottom Left: Fender Telecaster; Bottom Right: Klein Guitar, Collection of Ralph Gibson
61	Bottom: Courtesy of Orphée Lutherie, Paris; Top: Les Paul, Collection of Ralph Gibson
62	Collection R.F. Charle, Paris
63	Vinicus Canturia playing a Yamaha
64	Collection R.F. Charle, Paris
65	Anon., Portrait of Mary Osborne
66	Collection of Andy Summers
68–69	Les Paul Gold top, Collection of Ralph Gibson
70–71	Courtesy of Steve Klein, Sonoma, CA
72–73	Gittler Guitar, Collection of Ralph Gibson
74–75	KleinBerger, Steinberger GL-4, Collection of Ralph Gibson
76–77	Yamaha SLG, Collection of Ralph Gibson; Klein Guitar, Collection of Brandon Ross
81	Collection of Ralph Gibson
82–83	Collection of Orphée Lutherie, Paris
84–85	Collection of Andy Summers
88–89	Gibson L-4, Collection of Ralph Gibson
90–91	Collection of Marcello Gonçalves, Rio di Janiero, Brazil
92–93	Gibson Dreadnaught, Private Collection
94–95	Fender Jazzmaster, Fender Telecaster, Collection of Andy Summers
96–97	Fender Stratocaster, Collection of Ralph Gibson
98	Lefty Fender Telecaster, Collection of John MacEnroe
99	Jim Hall Signature by Roger Sadowsky, Brooklyn, NY
100–105	Collection of Andy Summers
106–107	Louden L-32, Collection of Ralph Gibson
108-109	Courtesy Martin Guitars, Nazareth, PA
110	Gibson ES-175,
111	Ibanez AS 200, Collection of Ralph Gibson
112	Gibson ES-175, Collection of Ralph Gibson
114	Gibson Custom Shop, Nashville, TN
116	Stromberg 400
117	Gibson L-5, Courtesy of Lark Street Music, Teaneck, NJ

Warm thanks to the staff at Chronicle Books for their expertise in bringing this book to fruition. Thanks are due to Florence Mann-Quirici, Caleb Cain Marcus, Arne Lewis, Randall Kramer, Lise Anderson, Julia Leavitt and Beth Schiffer for their help.

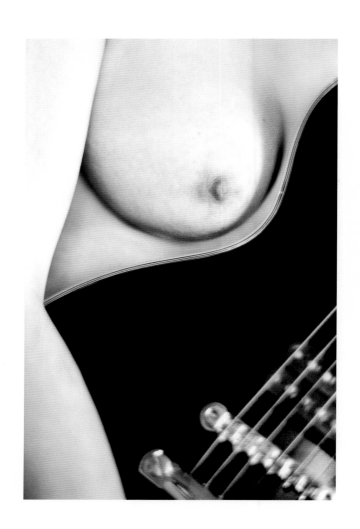